BEGINNING
HDR
PHOTOGRAPHY

Matthew Bamberg

Course Technology PTR
A part of Cengage Learning

COURSE TECHNOLOGY
CENGAGE Learning·

Australia, Brazil, Japan, Korea, Mexico, Singapore, Spain, United Kingdom, United States

COURSE TECHNOLOGY
CENGAGE Learning™

Beginning HDR Photography
Matthew Bamberg

Publisher and General Manager,
Course Technology PTR:
Stacy L. Hiquet

Associate Director of Marketing:
Sarah Panella

Manager of Editorial Services:
Heather Talbot

Senior Marketing Manager:
Mark Hughes

Acquisitions Editor:
Dan Gasparino

Project/Copy Editor:
Karen A. Gill

Technical Reviewer:
Donna Poehner

Interior Layout:
Jill Flores

Cover Designer:
Luke Fletcher

Indexer/Proofreader:
Kelly Talbot Editing Services

For product information and technology assistance, contact us at
Cengage Learning Customer & Sales Support, 1-800-354-9706.

For permission to use material from this text or product, submit all requests online at **cengage.com/permissions**. Further permissions questions can be emailed to **permissionrequest@cengage.com**.

Library of Congress Control Number: 2012934299

ISBN-13: 978-1-133-78877-5

ISBN-10: 1-133-78877-7

Course Technology, a part of Cengage Learning
20 Channel Center Street
Boston, MA 02210
USA

Cengage Learning is a leading provider of customized learning solutions with office locations around the globe, including Singapore, the United Kingdom, Australia, Mexico, Brazil, and Japan. Locate your local office at: **international.cengage.com/region**.

Cengage Learning products are represented in Canada by Nelson Education, Ltd.

For your lifelong learning solutions, visit **courseptr.com**.

Visit our corporate website at **cengage.com**.

Printed in the United States of America
1 2 3 4 5 6 7 14 13 12

To Jerome Larson

Acknowledgments

I'd like to thank my agent team, Carole Jelen and Zach Romano, who found me the opportunity to write this book. Daniel Gasparino, at Cengage Learning, assisted me through the process by providing support for my proposal and making sure it was successfully written. The editors of the book, Karen Gill and Donna Poehner, worked relentlessly checking my facts and steps and offered me not only positive messages about the book's content, but suggestions to make it a polished, one-of-a-kind work. Thanks also to Adobe and HDRsoft for making fine innovative software that would have been unimaginable just a few years ago. Finally, Alan Bamberg and Todd Larson assisted in evaluating the graphics and images used in the book, offering useful suggestions that helped me create them.

About the Author

As a freelance writer, **Matthew Bamberg** began taking photographs for hundreds of articles he wrote that were published in *Desert Sun*, *Palm Springs Life*, and *Riverside Press-Enterprise*. Curious by light striking his lens and the sounds of the shutter, he struck a relationship first with film and then, like so many, with the digital camera's sensor.

After traveling around the world as a photographer, he began printing, framing, and selling his photographs with mid-century modern themes in many Southern California stores. His books, *Digital Art Photography for Dummies* and three books in the *Quick and Easy Secrets* photography book series, describe the process from taking the picture to printing and framing it.

Matt is the author of more than 10 books to date. In *New Image Frontiers—Defining the Future of Photography*, Bamberg interviewed top world engineers, photographers, and gallery owners seeking to find answers to sensor research, new camera models (including the new mirrorless line manufactured by a number of companies), and the proverbial question: "How does a photographer get his work into a gallery?"

Aside from writing about f-stops, shutter speeds, and the fabulous job the software manufacturers have done to create unique photography applications that are redefining photography, Matt teaches Beginning HDR Photography online for University of California, Riverside (UCR), writing at the University of Phoenix, and education at National University.

Contents

Introduction

High dynamic range (HDR) photography has risen from an obscure process involving complex manipulation of photographs with mediocre software to a streamlined task with fine-tuned programs that all photographers from beginners to professionals can learn how to use.

The art of HDR photography begins with knowing the basics of shooting and manipulating photographs. Beginning photographers can learn photography basics while engaging in HDR photography.

What You'll Find in This Book

This book investigates the art and history of HDR photography, with the goal of teaching amateur photographers general photography concepts while they learn the particulars of HDR photography. It contains step-by-step tasks to create compelling HDR photographs, detailing the necessary equipment, software, and procedures.

The book begins with an analysis of HDR photography, including its history and use in art throughout the era that led to, produced, and advanced the photography process. You will learn how to implement general photography rules in all steps of HDR photography.

You'll also discover how to use the software you'll need for HDR photography. Photoshop CS5 and CS6 HDR Pro, Photoshop Elements, and Photomatix are explained, enabling you to produce numerous kinds of HDR photographs. Finally, you'll learn how to use Adobe Camera Raw (ACR), the primary program for tweaking photographs in the HDR process.

Who This Book Is For

This book is for photographers who are unfamiliar with the HDR photography process. It's intended for film photographers, casual shooters, artists, photography students, instructors, and anyone else interested in photography.

How This Book Is Organized

By reading this book, you'll gain knowledge of the history and integration of HDR into the field of photography. You'll discover which cameras are best for the shoot, from the models that make HDR photographs in-camera to those that have the appropriate settings and features to create the best HDR photographs.

The book gives step-by-step directions for using ACR, the primary program for preparing photographs for use in HDR programs. It illustrates the equipment, preparations, and setup needed for an HDR shoot in several types of settings and weather conditions.

The last part of this book covers the use of the most common programs that produce HDR and HDR-like photos. You'll read about the tone-mapping features of these programs and learn how to make an HDR-like photograph with a single photo.

PART I

All About HDR

CHAPTER 1
Dynamic Range Defined

Envision yourself on a long stretch of beach with the sun just over the horizon so that its reflection glides on the water to your eyes. Your pupils get smaller; they adjust to the light, letting you see some details in the water. Next, you move your eyes to the left, viewing pink cumulus clouds running like a waterfall to shades of orange and red, again your eyes adjusting in the rapidly changing light. Before you know it, the sun has sunk, seemingly inches below the surface of the earth. The sky darkens and turns navy blue. Your pupils get bigger as the night surfaces, and the dark blue sky turns black. Fixing your eyes on an object results in your getting used to the light, making it sharper after a period of time.

The preceding paragraph describes the details—dynamic range, if you will—of what you actually see. The human eye is able to adjust itself to see the world in a high dynamic range (HDR) view, which can be defined as a ratio between the lightest and darkest regions of a scene.

Cameras don't pick up as high a dynamic range as the human eye can. Printers pick up even less.

You've probably seen an HDR image on the Internet. If not, take a look at Figures 1.1 and 1.2, and you'll see the effect. The first two questions that come to people when looking at photos like these are

- Are they real?
- How were they created?

Figure 1.1 Dynamic range photograph showing cloud detail taken in Olympia, Washington.

Figure 1.2 Dynamic range photograph of enhanced reflection of boat in water taken in Olympia, Washington.

The answer to the first question is yes, they are real. The second answer is that they were created with an image processing program after photos were taken out in the field. Many photographers and artists think of HDR photographs as surreal, being similar, perhaps, to the colors and effects you'd see in a Salvador Dali painting.

The first concept that will help you understand all the options you have for creating HDR photos is to define dynamic range in terms of its relationship to a camera's sensor. For a camera's sensor, the definition of dynamic range can be updated to include the noise factor associated with taking a picture. Instead of the real-world definition of dynamic range being a ratio between the lightest and darkest regions of a scene, it is a ratio between the lightest region and the darkest region of a scene without a significant amount of noise (which is called the black level).

Dynamic range is also defined in terms of luminance, or the values that describe how much light is captured in a specific area. It is the ratio of two luminance (light) values. Julie Alder King in *Digital Photography for Dummies* describes dynamic range as the range of brightness values of an image. It's also referred to as the contrast ratio and is measured in stops.

Cameras with a large dynamic range show details in both highlights (before they are clipped, or become white) and shadows (before they are clipped, or become black).

Maximum dynamic range as defined by the website www.cambridgeincolour.com is the greatest possible amplitude between light and dark details in a photograph.

When you consider the resolution of the sensor, the value is misleading in terms of dynamic range. Very small sensors do not produce images with nearly as much dynamic range as larger ones do. If you look at Figure 1.3, you'll see a representation of 12 megapixel (Mp) cameras, each with different sensor sizes. The 12 divisions at the bottom of the sensor show that bigger sensors have larger pixels than smaller ones so that they can take in more photons of light per pixel. The lines at the bottom of each sensor represent how much surface area each pixel receives. On the bigger sensors, more light hits each pixel's surface area. That in turn makes the sensor more light sensitive, allowing it to pick up more information about color tones, thus increasing its dynamic range.

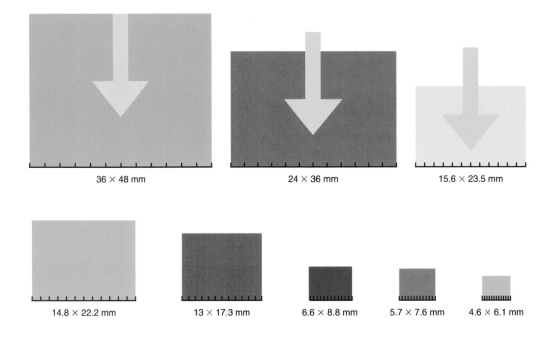

36 × 48 mm 24 × 36 mm 15.6 × 23.5 mm

14.8 × 22.2 mm 13 × 17.3 mm 6.6 × 8.8 mm 5.7 × 7.6 mm 4.6 × 6.1 mm

Figure 1.3 Amount of absorbed light by various 12 Mp sensors.

Given two 12 Mp cameras, one a digital Single Lens Reflex (dSLR) with a large sensor and one a point-and-shoot (with a much smaller sensor), each pixel on the dSLR camera sensor gathers more photons of light than on the sensor of a point-and-shoot when the cameras are set to the same shutter speed and aperture. When you have more photons of light, the photo has a greater dynamic range.

The reason cameras with more megapixels look sharper when making a print of the same size from a lower-megapixel camera is that the image taken with a higher-megapixel camera doesn't get the noise enlarged as much as the one taken with a lower megapixel camera. In the former, the noise is hard to see.

The sensor type also affects dynamic range. A charged-coupled device (CCD) sensor has a higher dynamic range than a complementary metal oxide semiconductor (CMOS). (See www.teledynedalsa.com/corp/markets/ccd_vs_cmos.aspx.) More cameras contain CMOS sensors than CCD sensors because they are cheaper to produce.

On a more basic level, you can find the dynamic range of a camera by testing its sensor, a process that requires taking pictures at various exposure levels. Two images are culled from the series: one that shows as little light as possible but still allows you to make out details before underexposure, and one taken with a lot of light that still shows details before overexposure.

DxOMark, an organization that rates cameras and lenses, calculated which sensors take landscape images with the highest dynamic range. Its testing of the dynamic range of landscape photos taken with many different camera models (most with different sensors) ranks models and associated sensors from greatest to smallest dynamic range. The top camera was the Pentax K-5. Table 1.1 shows this camera and the other top five with sensor sizes and megapixel count. The size of the sensor doesn't always mean that the camera will have a higher dynamic range.

TABLE 1.1 dSLR Sensor Sizes and Resolution

Camera Model	Resolution	Sensor Size	Sensor Type
Pentax K-5	16 Mp	23.7 X 15.7 mm	CMOS
Nikon D7000	16 Mp	23.6 X 15.6 mm	CMOS
Nikon D3X	24 Mp	36 X 24 mm	CMOS
Nikon D5100	16 Mp	23.6 X 15.6 mm	CMOS
Fujifilm FinePix	S5 (and S3) Pro	23 X 15.5 mm	CCD
Sony Alpha 580	16 Mp	23.5 X 15.6 mm	CMOS

Note that the D5100 is also Nikon's first SLR to include in-camera HDR imaging capability. You'll learn more about this HDR camera in Chapter 14, "In-Camera HDR Processing." Also, be aware that the dynamic range is lost in most point-and-shoot cameras because there are too many pixels in such a small area.

In Figure 1.4, take a look at A and B. A and B have the same dynamic range but a different distribution of tones. The same thing is true for C and D, which have the same dynamic range, each with a different distribution of tones. Now take a look at A and C. Each has an even distribution of tones, as do B and D.

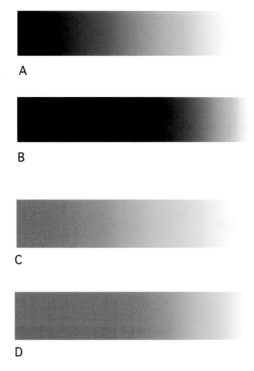

A

B

C

D

Figure 1.4 An HDR photo can be limited in the number of tones it has.

Tone mapping is the most important part of tweaking HDR images. It's the process by which images are made to simulate HDR because HDR images have tonal information that can't be seen by today's monitors and printers. Tone mapping approximates how an HDR image would look provided you had a monitor that could handle all the tones. The difference between the two is that you can tone-map a single image (as well as multiple images put together) by creating overexposed and underexposed copies using Adobe Camera Raw (ACR). (See Chapter 4, "Adobe Camera Raw Photograph Attributes.") You can also use tone-mapping tools (sliders) in software such as Photoshop to tone-map any image.

A tone-mapped single image is likely to have significant noise because you are attempting to bring back the details of an image the camera can't capture in one exposure. For example, if you shoot into the sun, the sky will appear white in a normal exposure. To get a photo that shows the blue sky for merging, you must underexpose it (at the expense of leaving the foreground dark). An image tone-mapped after merging three exposures taken with a camera catches many of the details by including under- and overexposed exposures.

If you've ever tried to recover all the details from shadows by adding fill light in ACR, you'll find that there's a point at which shadows will be filled with noise, so much so that it's difficult to see the details clearly and you realize they're not entirely recoverable. This tool is designed to recover detail in the shadows in an attempt to tone-map a single image. You can only go so far with ACR before noise and image contrast distortion become a significant problem. This is why you want to tone-map three different images to create a real HDR photo.

JPEG OR RAW

You might wonder which is a better option to shoot in when creating an HDR photo: JPEG or Raw. JPEG is a compressed photo, losing data when it's compressed in-camera. This is why JPEG file sizes are smaller and have a smaller dynamic range. However, you can still use tone mapping to tweak JPEG files (see Figure 1.5). Raw, on the other hand, is a lossless format, a format where there is no compression, thus no loss of data and a larger dynamic range. This creates a larger file and gives you the opportunity to recover some details in the shadows when post processing. You'll read more about file types in Chapter 29, "File Types for HDR."

Figure 1.5 Tone-mapped JPEG image from an iPhone.

Although Raw is recommended, you can still do anything you want. Digital HDR is a new art, and the sky is the limit. Try everything from tone mapping a single image to creating an HDR photo from ten. To be sure, people do create some unbelievable photos using a single JPEG (go to www.flickr.com/groups/single_jpg_hdr/) even with the simplest cameras.

If you look at Figure 1.6, you'll see a photo exposed so that the water doesn't contain blown highlights, which makes the background dark. To be sure, you can bring that background in ACR with the fill light, as shown at 100 percent resolution in Figure 1.7, but it has too much noise. If you had an HDR photo, the program you used would have accessed an overexposed photo you would have taken (see Figure 1.8). Most of what you see in Figure 1.9, which is Figure 1.8 at 100 percent resolution, could be accessed in an HDR processing algorithm, giving the dark area of the merged photo clear detail.

Figure 1.6 Photo of water has details and dark background.

Figure 1.7 Photo after increasing the fill light.

When you do this, you are tone mapping. In HDR photography, you want to tone-map with three different images, so you can borrow the noise-free parts of the images to appear in the final merged image. Software such as Photoshop HDR Pro and Photomatix use many algorithms to tone-map. You'll learn more about that in Chapter 31, "Photoshop CS5 and CS6 (HDR Pro and Working with Settings)," and Chapter 34, "Photomatix Options."

Figure 1.8 Overexposed shot so that rocks show up.　　**Figure 1.9** Close-up photo shows no noise.

Now that dynamic range has been defined and you know how it's associated with an HDR photo, we can move on to investigating how dynamic range evolved throughout history. You'll discover that dynamic range photography has been around quite awhile. Its most recent resurgence came about with the advent of digital photography.

Dynamic Range Photography History

For centuries, visual artists have manipulated their work by creating stunning lighting so that their paintings would appear to have a high dynamic range (HDR). Two methods they used included saturated opposing colors and outlining their work in contrasting colors so that it would appear to increase the dynamic range of the work. One method—chiaroscuro—works by creating stunning lighting contrasts encompassing the entire painting to add dimension to the scene.

Before the Renaissance, many painters created work with uniform lighting.

In the late 13th century, Giotto di Bondone painted what's referred to as *The Expulsion of the Demons from Arezzo*, which is divided into light uniform tones on the buildings and darker ones making up the hectic sky.

During the Renaissance, many artists changed their techniques; their paintings became filled with highlights and shadows, partially used to enhance a story being told. Leonardo da Vinci was one of the first artists to introduce this kind of illumination. One of the reasons for the change was that before the Renaissance, paintings were pictorial for recording events, attracting little attention from viewers.

During that time, chiaroscuro, an HDR-like illumination, became popular. Piero di Cosimo's *The Visitation with Saints Nicholas and Anthony* encompasses an assortment of tones throughout the composition. Also, the number of painting aficionados increased, so the medium became a popular art form.

A few years after the inception of photography in the 1820s, photographers found that they couldn't expose a landscape photograph correctly. They found that when they attempted to expose the sky correctly, the land in the photograph became underexposed. When they exposed the land correctly, the sky appeared overexposed. No doubt, you probably have seen the same thing happen in your photographs.

Throughout history in both film and digital, if you set the focus point on the sky, it will be beautiful, especially if there are unique cloud formations, but at the expense of the land. Figure 2.1 shows an image exposed according to the light in the sky, which produces less detail in the ship and great detail in the sky. The opposite is true when you set the focus point on the land; the ship is filled with detail, as seen in Figure 2.2, but at the expense of losing sky detail.

In the 1850s, along came French photographer Gustave Le Gray, who discovered that if he made two exposures—one that exposed the sky correctly and another that exposed the land or sea correctly—he could put the two images together so that everything in the combined image would be properly exposed. In effect, what he was doing was bringing out the details of the entire scene without sacrificing details of one part for another. See Figure 2.3.

Figure 2.1 Lots of detail in the sky at the expense of less detail in the building that's been made to look like a ship.

Figure 2.2 Lots of detail in the land at the expense of less detail in the sky.

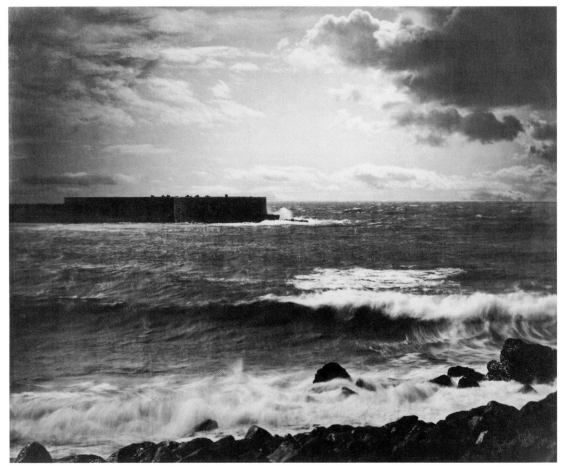

Figure 2.3 The Great Wave, about 1857, Gustave Le Gray
The J. Paul Getty Museum, Los Angeles.

LUMINOSITY

Luminosity (also called luminance) is the degree of darkness and lightness in a photo, which is determined by the amount of light reflected from a surface. It's different from brightness in that it can be quantified as the energy emitted per unit area. Hue, saturation, and lightness affect the luminance of an area. For example, yellow has more luminance than blue. Green has more luminance than red. Heavily saturated orange has more luminance than a shade that's lightly saturated. Light colors have more luminance than dark colors, and the luminance increases when a color is lit by sunlight.

Of course, the luminance is going to be much greater in areas upon which the sun is shinning and much less in shady areas, a factor caused by the amount of light reflecting off (or through if transparent or translucent) sunlit objects versus light reflecting off shadowed object/subjects.

When discussing luminance, you can't avoid talking about contrast because contrast is the differential of luminances between two areas or regions of a photo. Contrast can vary a little bit over short distances (which is part of what creates an HDR photo) and can vary a lot over large distances.

High luminance objects will figure prominently into your HDR photos because they will appear to "pop out" of the photo. If the entire photo has a high luminance, the HDR process will bring the luminance down—not a very good situation for an HDR photo. If the photo has high luminance in the foreground and low luminance in the background, like the plant in Figure 2.4, you have an effective photo without HDR. If you make an HDR photo out of it, you'll lessen the contrast between foreground and background, making the photo less effective.

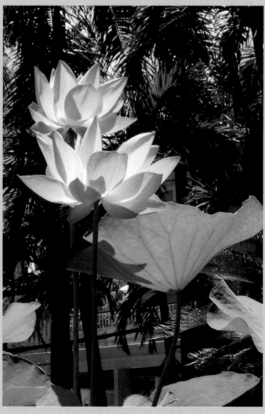

Figure 2.4 The dark background helps make the flower stand out.

Generally, when you create an HDR photo, you want to increase the luminance in the shadowed areas to show the detail. Figure 2.5 shows an image taken at 0 exposure compensation at dusk. Although there is high-contrast lighting in this image, the contrasts don't work over small distances. You want more blue in the sky, and you want the dark areas to have more detail so that they are enhanced with HDR (if you had taken the underexposed and overexposed shot). Figure 2.6 shows how much improved the image is when it is converted to HDR. The overexposed shot provided detail in the shadows, and the underexposed shot made the sky more blue; however, you have decreased overall contrast, something that you have to consider when tweaking a photo using HDR software. (You'll learn more about how to do that in Photomatix in Chapter 34, "Photomatix Options.")

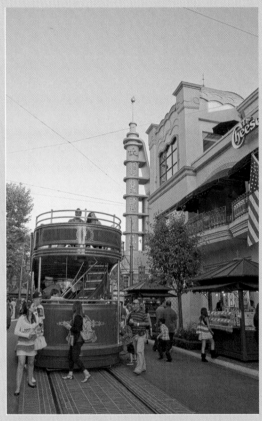

Figure 2.5 Image at 0 exposure shows high contrast over whole area but low contrast over small distances.

Figure 2.6 Image improves after making it HDR, but at the expense of overall contrast.

Henry Peach Robinson, like the painters of the Renaissance, photographed not only to re-create a scene, but to make viewers respond to the situations he presented. Robinson was much like other photographers of the day who valued pictorialism, or making a photograph that looks like a painting. This involved a technique that is much like using layers in Photoshop. The downside to Robinson's creativity is that he used so many hazardous chemicals that he succumbed to their effect and wasn't able to work with them after he was 34.

A few years after Le Gray used two negatives to make one photograph, Robinson used several. In the photograph *Fading Away*, Robinson used several cut glass negatives, each taken at a different exposure, as is apparent when you look at the clouds out the window. The clouds contain much detail because Le Gray divided up the photograph, using several negatives, each exposed differently to get details in both the shadowed and lit areas. Just so you know, the photograph was staged.

By the twentieth century, as pictorialism ran out of favor, realism took over so that photographers could capture a scene with as much detail as viewing it in person. Photographers did this by using small apertures to create a large depth of field. However, underexposed parts of photos were not manipulated using the methods photographers used before this time.

Paul Strand was the innovator of the realism movement, often called Straight photography. Strand often photographed real objects and shadows to create abstractions, which was a different take on photography at that time. Russian photographer Alexander Rodchenko used multiple exposures, but not to create HDR-like works. He used them for special effects such as adding the face of a man to the back of the head.

The master of landscape photography, Ansel Adams, was a realist who photographed with small apertures using a medium format camera so he could get sharpness throughout the frame. Adams knew that the results that came from his camera were going to be different from what he shot on film and what he got on paper, so he accounted for it while shooting with the zone system. He made his photographs appear HDR-like by using a zone system, whereby he'd assign image parts to different zones for printing. He previsualized the landscape, relating it to the tones that would come up in prints. He'd get detail by using dodging and burning, much like we do when we use those Photoshop options today. Adams's zone system has been likened to a 1940s chemical Photoshop.

Dynamic Range in Digital Photography

Each step of developing an image goes through dynamic range changes. Your camera has a different dynamic range than your monitor, and your monitor's dynamic range is different from that of your printer. You can make smaller files look like they are high dynamic range (HDR) on the Internet because they are compressed in JPEG format, which uses a compression algorithm tuned to the human eye. In essence, the photo can lose data during compression, but that data doesn't affect the way humans perceive it when it's resized.

Recall that, to get HDR, you have to combine two or more photos taken at different exposures. When you are learning how to make HDR photos, you first have to know some general information about photos taken with one exposure so you can understand that when you tweak the shadowed areas with Photoshop, they are highly susceptible to noise, and it is impossible to recover details in areas where blown highlights occur. This is why you can't make a true HDR photo with one exposure. This doesn't mean you can't emulate one, though. You can do so because of the noise reduction capabilities available in Adobe Camera Raw (ACR). This process is discussed in Chapter 4, "Adobe Camera Raw Photograph Attributes."

You'll be using exposure compensation (measured in exposure values notated as EV) frequently when taking HDR photos. The numbers here indicate stops:

–2_ _–1_ _0_ _+1_ _+2

A stop is a unit of exposure measurement associated with the values of aperture and shutter speed that are equal to one stop. Doubling exposure results from moving it one stop up. A stop down means halving the exposure. Each line between the numbers represents one-third of a stop. The number 0 represents what the camera judges as good exposure (Figure 3.1). Much of the time, the camera doesn't achieve this, creating an opportunity for the photographer to adjust it, turning the dial and manipulating the stops.

Often, digital photographers refer to stops when explaining exposure. A digital camera has 6–9 stops, whereas the human eye has about three times more. There are two ways to look at capturing HDR in photography: one way is to shoot in Aperture Priority mode with the aperture set according to how much of the photo you want sharp and then setting the exposure compensation 2 stops below for an underexposure (Figure 3.2) and 2 stops above, for an overexposure (Figure 3.3). Figure 3.4 shows the result when you merge the images together in a program called Photomatix. (See Chapter 34, "Photomatix Options.") If you figure that 1 stop above is two times the amount of light that is let in through the lens and 1 stop below is one-half the amount let in, then 2 stops above would be four times the amount let in, and 2 stops below would be one-quarter of the light let in. The other way to shoot HDR sets is to use Manual mode, where you first decide an aperture at which to shoot your HDR set and then change the shutter speed by different amounts to create the exposures. Either way, you'll need a tripod if the light has you setting your camera to a shutter speed below 1/30 seconds.

Figure 3.1 Normal exposure EV 0.

Figure 3.2 Underexposed image taken at EV –2. **Figure 3.3** Overexposed image taken at EV +2.

Many cameras have an option called AEB (Auto Exposure Bracketing), which can be set according to how many stops you want of under- and overexposure. This comes in handy when you want to shoot without a tripod. The rapid shots (3–8 frames per second) catch a scene quickly so that you can put it together with an HDR processing program. In essence, this is the key to expanding dynamic range of handheld shots. It won't give you the best results, but it is the minimum required for an HDR photo.

Keep the ISO speed in mind when shooting digital photography. When shooting with a tripod, you can always keep it at 100 ISO, the speed that will give you the least amount of noise and the best detailing of the contents in the frame. If you're shooting handheld, you have to increase your ISO speed. There's a good possibility that the overexposed image will blur because the shutter will be open the longest in the shot set. For this reason, 400 or 800 ISO is a good bet for keeping your resulting HDR image sharp.

Figure 3.4 Image after Photomatix manipulation.

PART II

HDR Camera Attributes

CHAPTER 4
Adobe Camera Raw Photograph Attributes

I n high dynamic range (HDR) photography, working with Camera Raw photos is best. Unlike a JPEG file, which is processed in-camera, a Camera Raw photo hasn't been processed, enabling you to perform the processing. To be sure, the camera's hardware can process a photo much faster than a Camera Raw image processing program can, but when you edit in Camera Raw, you can always go back to the original settings at which the image was shot.

When you're using Photoshop to make an HDR photograph, you're going to need to use Adobe Camera Raw (ACR) before and probably after you merge the photographs, regardless of the programs you are using to convert to HDR. ACR provides a platform through which you edit your photo without degrading it. Note that when you edit a Camera Raw photo in the main program in Photoshop, you can't save it in that format. It's best to keep the original Camera Raw photo after shooting because you can go back to it and re-edit at any time. Another nice thing about Camera Raw files is that you can open multiple images in the Photoshop program ACR and change them together (Figure 4.1).

Figure 4.1 Multiple images loaded into ACR.

FROM 8 BITS/CHANNEL TO 16 BITS/CHANNEL IN ACR

After you open the file, you can see that the default setting is 8 bits/channel. That information appears at the bottom of the ACR window (see Figure 4.2). If you move your cursor over that information, you will discover it is a link. Click on it, and you're given a choice of values for the bits per channel (see Figure 4.3).

Figure 4.2 Default for ACR image display is 8 bits/channel.

When you are working in ACR, you can change the bit depth (Figure 4.3) so that more information about color is included in the image. When you do this, your changes are less likely to be pixilated, especially when you're working with very bright and dark areas. (Bit depth is explained in Chapter 8, "Color Bit Depth.")

Figure 4.3 Window of selections opens when you click on bit information.

Click on 16 bits/channel, and your image will provide twice the amount of color information. When you're finished, click Done. This won't change the file size of the Raw version of the image, but when you open the image after changing it to 16 bit and save it as a TIFF file, the file will be twice the size as if it were saved as an 8-bit image.

You can select multiple Raw images (the normally exposed one first and then the ones that were taken with exposure compensations other than 0) either in Adobe Bridge or on your Desktop (or wherever the files are located) by holding down the Shift key and clicking on each file you want. On the Desktop, Ctrl-click (on the PC) on one of the selected files and choose Open with Photoshop, which puts them in ACR automatically. In Bridge, just double-click on one of the selected files. After you do this, the images come up in ACR, as shown in Figure 4.4.

Figure 4.4 Multiple images loaded into ACR.

Because this is the beginning of the HDR process, start by adjusting a few options in ACR before using Photoshop Merge to HDR software, primarily color temperature (white balance), chromatic aberration, and lens vignetting.

After opening the photos you want to merge in Pro HDR, Photoshop CS5's and CS6's HDR merge option, check to see if the white balance is correct. To do this, set ACR to 100 percent resolution and zoom into what should be a neutral-colored object. Move the temperature slider until it is a neutral color.

Next, you can remove the chromatic aberration, if there is any. Chromatic aberration is the term for bands of color at the edges of surfaces (see Figure 4.5). To check for it, view your photo at 100 percent resolution. Figure 4.6 shows you some blue chromatic aberration found after moving to the different areas of the image along the man's shirtsleeve. You can clear that up by moving the

sliders that are located in the Lens Corrections tab (fifth icon from the left) under the histogram in the view window (see Figure 4.7). Move the Fix Red/Cyan Fringe and/or the Fix Blue/Yellow sliders until you don't see any of the bands. Select All Edges in the drop-down navigation bar.

Figure 4.5 Look along the edges of people and objects for chromatic aberration.

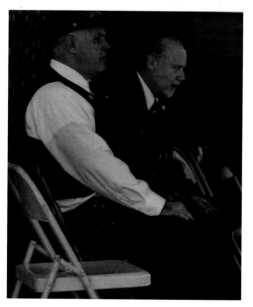

Figure 4.6 Chromatic aberration in part of photo.

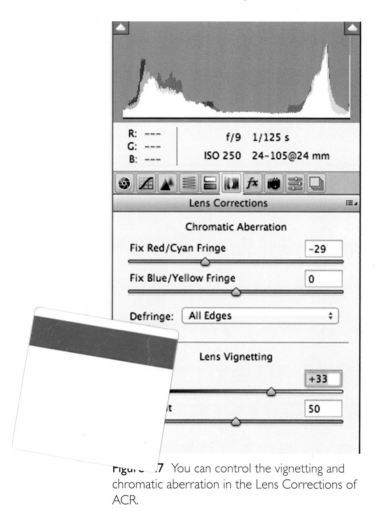

Figure 4.7 You can control the vignetting and chromatic aberration in the Lens Corrections of ACR.

To fix the vignetting (change of color at the edges of the frame of the photo), adjust the Lens Vignetting sliders (see Figure 4.8). Most of the time, adjusting the Amount will do the trick without having to tweak the Midpoint. Finally, select all the photos using the Select All button and click on the Synchronize button. Both buttons are at the top-left corner of the ACR window. In the next window, click OK. You do not have to change any of the default settings in that window. Last, click on Done. You can now open your photo in any program you choose to create an HDR photo from the photos you've tweaked in ACR.

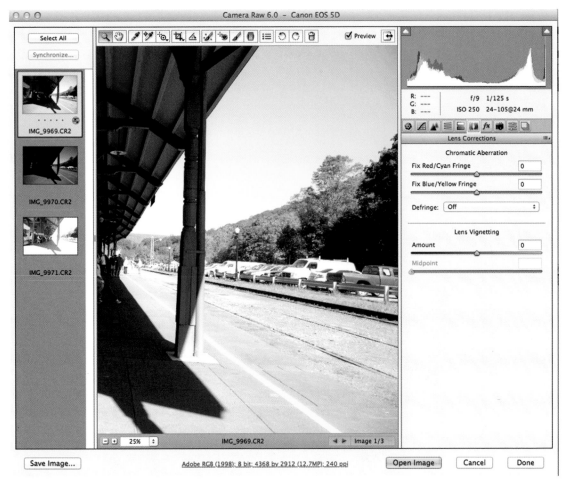

Figure 4.8 Vignetting, which can be easily eliminated, is most obvious in the corner of images.

One last thing about ACR: You can make Photoshop open any file so that it is viewed and tweaked in ACR. This option is limited to photos with bit depths of 8 or 16 bits/channel. More about that in Chapter 8. Because JPEG is lossy, if you edit its ACR by making changes to it and save it again, it will be destructive, which refers to the degrading of an image. It's best to convert to TIFF if you are going to do this. Note that opening any type of file in any software and closing without saving edits is a nondestructive (no image degradation) action.

I generally use ACR for all my photos because there are many easily accessible options in that window. Note that the Photoshop default is to open only Raw photos in ACR (Disable JPEG Support and Disable TIFF support). To change that, navigate to Photoshop > Preferences > Camera Raw. A window opens like that in Figure 4.9. Navigate to the JPEG and TIFF handling section at the bottom. Use the drop-down menu bar to select and click on Automatically Open All supported JPEGS and Automatically Open All Supported TIFFs.

Figure 4.9 You can open any JPEG or TIFF file in ACR by changing the preferences.

Brightness

Brightness is the identification of the perceived luminance changes that occur in an image. Most often, when you increase the brightness of the image, you give up details of the lightest areas of the image; when you decrease it, you give up details in the darker areas of the image.

One of the biggest dangers of brightness is that when you tweak it, you risk getting blown highlights and clipped shadows. When the highlights have been clipped, you've lost detail in them because they've been forced to pure white.

Surfaces upon which the sun is shining directly, as shown in Figure 5.1, are most susceptible to blown highlights.

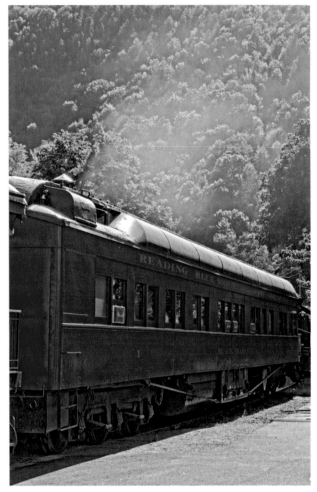

Figure 5.1 Note the lost detail in the area of blown highlights at the top of the train.

If you take a look in Figure 5.2, you'll see that there is detail in the tallest building. Brighten it, however, and you'll lose it, as shown in Figure 5.3. This is something you have to watch carefully for when you're tweaking high dynamic range (HDR) photos both in the HDR processing program and in Adobe Camera Raw (ACR). Note that you have more latitude with the Brightness

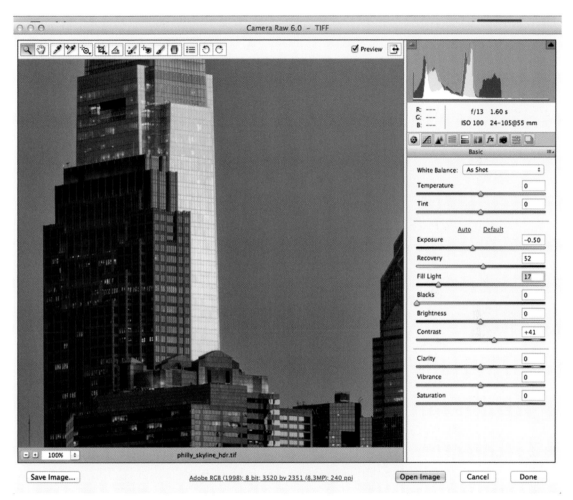

Figure 5.2 Detail can be seen on tallest building.

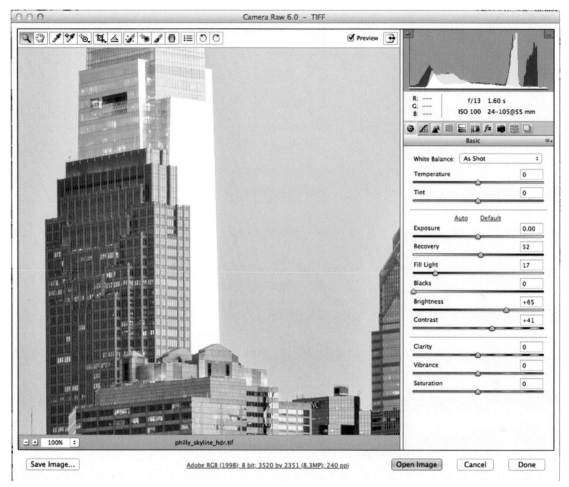

Figure 5.3 Brighten an image too much, and you'll get blown highlights in it.

slider in terms of avoiding blown highlights than with the Exposure sliders, which blow them with even less of a slider pull.

The biggest concern regarding the histogram is areas of the photo that have lost detail. Whites, reds, blacks, and other colors can appear uniform, losing all detail. We call this clipped (or blown) highlights when detail is lost to pure white and clipped shadows when it is pure black. Once you've lost detail to blown highlights, there is no bringing it back. You can tell you have unrecoverable blown highlights in ACR by moving the exposure slider as far to the left as it will go. If the lightest area of the image still shows no detail, you're not going to be able to recover any of it. The detail in the clipped highlights at the top of the train in Figure 5.1 is unrecoverable. On the other hand, there is the possibility of bringing back some detail in the darkened shadow

JUST WHAT IS A HISTOGRAM?

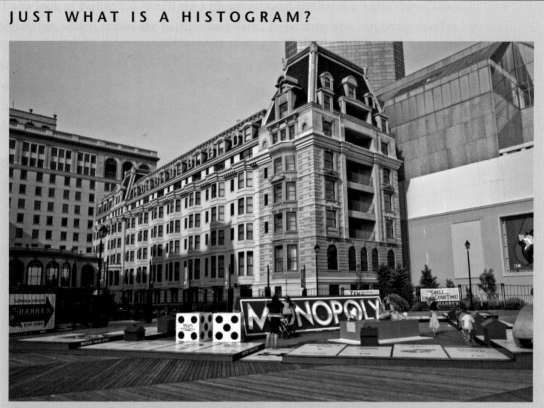

Figure 5.4 HDR image of Atlantic City boardwalk.

Histograms are graphs of lightness, or tonal ranges, that tell us about the exposure of a photo. You can see histograms in many parts of the photography process. The histogram display on your camera lets you know how well exposed the shots are that you are taking. You can access the histogram through the Info button on Canon cameras. To get the histogram display, just keep pressing on the Info button until you see the display come up on top of the image that appears on the LCD screen. To find out where the histograms are on other camera models, see the users guide. You can also view a histogram of your photo in the Photoshop Levels option (Image > Adjustments > Levels). The histogram in Figure 5.4 for the Atlantic City HDR image shows a well-exposed photo.

Recall the image of the train discussed earlier. Look at the histogram of it in ACR (Figure 5.5), and note how the various colors rise to peaks in areas of it. Histograms in ACR are in color. They show red, green and blue (RGB) colors. Two overlapping channels show yellow (red and green), magenta (red and blue), and cyan (blue and green). When all three channels overlap, you get white, which is a mix of colors. Can you make some deductions about the histogram for the train photo?

Figure 5.5 Histogram for Atlantic City boardwalk image.

The horizontal axis shows the tonality of the colors. On the left side of the histogram are the darkest tones (underexposed); on the right are the lightest ones (overexposed). The vertical axis shows the number of pixels of light in the photo by color. The taller the color peak, the more of that color there is in the photo; the smaller the peak (or larger dip), the less of that color.

In the histogram of the photo of the train (Figure 5.6), you see that most of the reds (large peak, so there is a lot of red in the photo) are darkened significantly, and the greens (small peak, so less green) are darkened just a little. Notice the smoke. It is subdued, which means it is underexposed. Believe it or not, the color of the smoke is mostly cyan—so you have underexposed cyan limiting the smoke detail.

So what does all this tell us? The first thing that comes to mind is to increase the cyan that appears in the photo (navigate to HSL/Grayscale > Hue > Blues and move the slider toward cyan) to make the smoke more visible (Figure 5.7). You can see that the histogram has changed—more cyan was added to it, giving it a higher peak that is a bit overexposed.

Figure 5.6 The top corner of the ACR window contains a color histogram.

To enhance the HDR look of the photo, you can tweak certain ACR options according to what the histogram reported. To get rid of the cyan smoke, you just desaturate the blues (navigate to HSL/Grayscale > Hue > Blues), coming up with a more natural-looking image, as seen in Figure 5.8.

Figure 5.7 Smoke is composed mostly of cyan.

This is just one of hundreds ways you can change the photo, all of which will result in changes in the histogram. The nice thing about these changes, unlike those in the main Photoshop program, is that they are nondestructive because the Raw file has all the possible information about the image at the time it was taken.

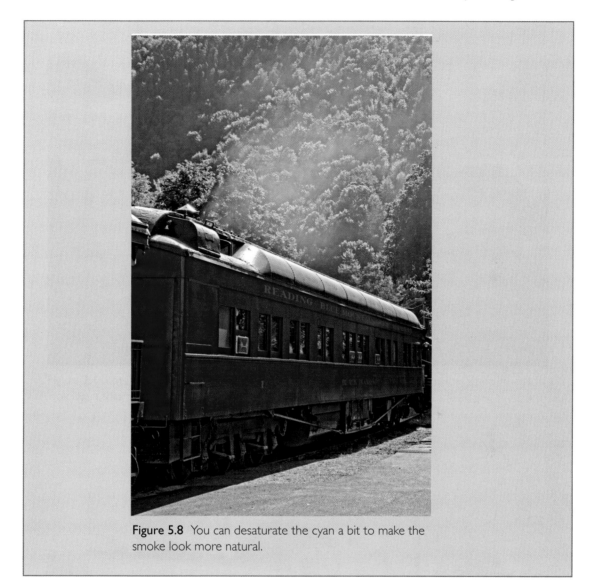

Figure 5.8 You can desaturate the cyan a bit to make the smoke look more natural.

CHAPTER 6
Contrast

When you look at the world around you, your eyes are constantly making adjustments so that what you see is constantly changing. Have you ever entered a darkened room from a well-lit room and seen that adjustments take place as the colors of the objects in the dark room slowly appear?

If our eyes worked like a camera, we wouldn't be able to make out the detail around us if our eyes are looking toward the sky, and we wouldn't see much detail in the sky if our eyes are focusing on the land. That's not how human vision works, though. We're fortunate that our pupils dilate when we're looking at dark areas and contract when we're looking at light areas. This creates a world that is exposed the way we would like on film and sensors.

Tone mapping works by utilizing what we know of this process to create a lower contrast version of a high dynamic range (HDR) image that still looks like it has the contrast of the original. It attempts to create a version that might represent what we could have seen rather than what a camera would.

You might have noticed that when you increase the contrast of an image, the image looks sharper, and when you decrease it, the image looks softer. Let's take a look at what actually happens when you have maximum and minimum contrast in Adobe Camera Raw (ACR).

Contrast is related to sharpness in that you recognize a sharp photo because of the high-contrast edges of items in it. A good way to compare contrast and sharpness of a photo is to look at blown-up images. Figure 6.1 shows a bamboo shot that was taken in Huntington Gardens in Pasadena. I broke up the shot into the following blown-up (400 percent) parts: contrast as shot in sharp part of photo, maximum contrast, minimum contrast, and contrast as shot in soft part of photo.

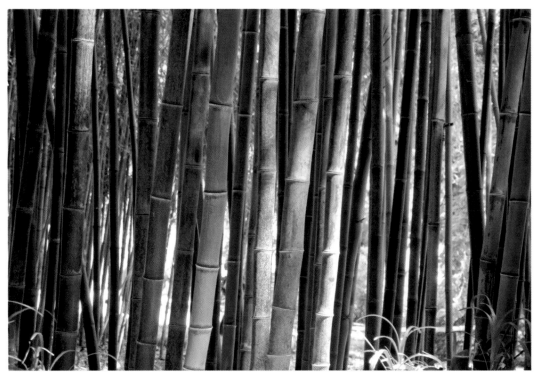

Figure 6.1 Bamboo picture with sharp and soft areas taken at f/14 for .5 seconds at 105 mm.

Let's first compare the contrast at the edges of the photo in the sharp part of the photo (Figure 6.2) with the soft part of the photo (Figure 6.3). In the sharp photo, the edges are well defined; in the soft photo, they are pixilated and have no well-defined edge.

Figure 6.2 Contrast in sharp area of bamboo plant.

Now notice the extensive noise that runs along the plant in Figure 6.2. When you up the contrast, the noise disappears into black thus giving the high contrast shot a sharper look (Figure 6.3). It's not really sharper, though, because all that was done is that the side of the bamboo stock were clarified by adding black along it. You'll find when the contrast is increased too much there are more dark areas in the image, which results in color loss.

Next, you can probably predict what happens when you lower the contrast. If you think it adds noise and softens edges, you are correct (see Figure 6.4), but it also adds some color. For this reason, you often have to lower contrast in shots taken at midday when the sun's rays cast dark shadows, masking much of the color in the photo with a dark hue (see Figure 6.4).

When you make an HDR photo, the contrast also changes in a process that's called tone mapping. The algorithm alters the contrast between the edges of subjects and objects adjacent to the background, which is why you get such good results.

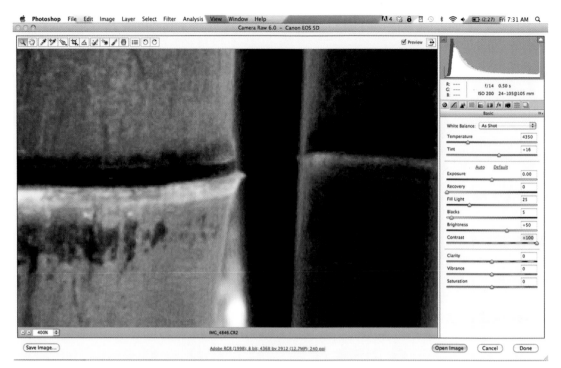

Figure 6.3 Increased contrast in ACR makes the photo appear sharper.

Figure 6.4 Image at Low contrast in ACR adds noise and softens edges.

FINDING CLIPPING IN ACR

Most of the time, you want to avoid clipping in the final HDR photograph. Clipping is when a color is beyond the highest color value the monitor can accept or lower than the lowest color value that the monitor can accept. Clipping results in blown highlights, shadows with few or no details, or flat colors with a loss of detail over a specific area of the photograph. Note that when you are out in the field taking photographs at different exposures for an HDR photograph, you'll get lots of clipping in some photographs, especially if they are over- or underexposed. You really don't need to worry about clipping until you are finished merging the photographs.

There's an easy way in ACR to find out exactly which areas in your photograph have blown highlights and darkened shadows. If you click on the little triangle located in the top-right corner of the histogram in ACR, the program reddens any clipped highlights as shown in Figure 6.5. This is called a highlight clipping warning. If you do the same thing over the top-left corner of the histogram, you get black areas in your photograph. This is a shadow clipping warning.

Figure 6.5 Options exist in ACR to show clipped highlights and shadows.

In the final tweaks of your HDR photograph, you'll probably want to get rid of as many of the clipped areas as you can. You do this by moving some of the sliders, which is discussed in the next chapter.

Color and Saturation

C olor has to do with the light that is being reflected off a surface. When an object reflects all colors, it is white because white is made up of all the colors combined. When an object appears blue, it is reflecting only that color and absorbing the rest.

Saturation is the degree to which gray is added to a color, or the color's intensity. A fully saturated color is pure. For example when you see a fully saturated blue, there is no gray added. When you lessen the saturation gray is added to the color. Take away the saturation and all you'll have left are different shades of gray, or what is called a black-and-white photo.

One of the biggest complaints about high dynamic range (HDR) photography is that it is oversaturated. Oversaturation is not what HDR is all about. It's about getting a broader range of tones, and some saturation can do that. What's better about Adobe Camera Raw (ACR) and HDR programs is the Vibrance option, which is prone to less clipping when enhancing color than the saturation slider is because it selectively chooses the muted colors to enhance.

When you increase saturation, you lose color details. Losing color details due to oversaturation is called channel clipping because photographs are made up of different color channels. It can cause posterization, which is a reduction of tonal differences among gradations. An image can be so posterized that it has only a few tonal difference throughout the entire frame. Yes, you can do that by maximizing all the sliders with Photoshop's Smart Sharpen option (Figure 7.1). HDR could be considered diametrical to posterization.

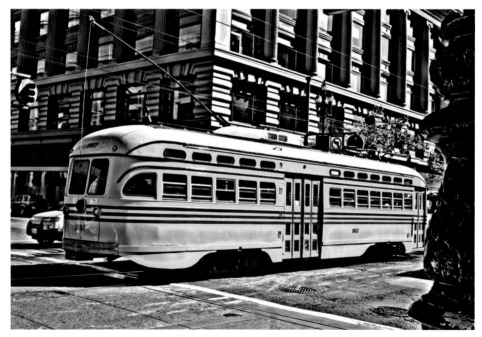

Figure 7.1 A posterized image.

Whereas clipping occurs when you overexpose or underexpose a photograph, oversaturation results in loss of detail of fine color changes—clipping of the red, green, or blue channels.

This might leave you to believe that when there's clipping, the best way to get rid of it is to lower the saturation or vibrance. Not so. Here the recovery slider works best. You only need to adjust up a little bit to get rid of the clipped red. You can tell when it's gone when the tiny red arrow indicator disappears on the top right of the ACR window or when the red on the histogram doesn't reach the far-right end.

Figure 7.2 shows the histogram with the red arrow indicator, and Figure 7.3 shows that the saturation needs to be decreased significantly for the clipped reds to move away from the edge. Figure 7.4 shows that the recovery slider needs to be increased only a little bit for the clipped red to go away.

Figure 7.2 ACR shows clipping of red channel.

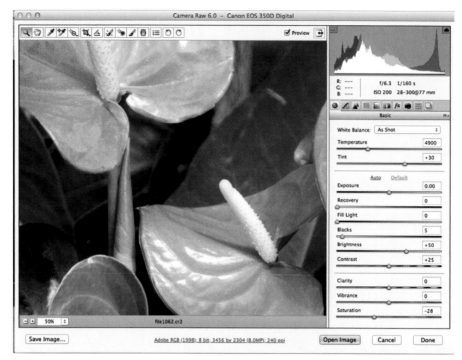

Figure 7.3 Saturation has to be greatly reduced to get rid of the clipping.

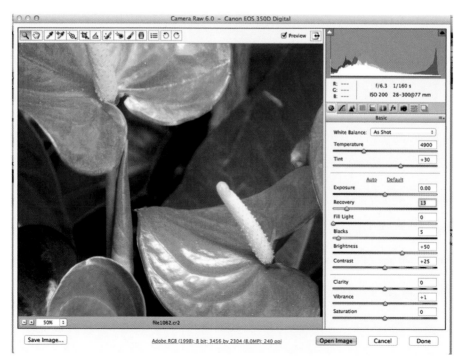

Figure 7.4 The recovery slider is much better for taking away clipping.

Color Bit Depth

C olor bit depth is associated with the range of color over a specified area. It is the smallest piece of data that your computer stores to record color. A small color bit depth indicates that the gradient of the image contains fewer tones than an image of greater color depth. Higher bit depth gives you smoother color variations.

Bit depth is measured in bits per channel. In Photoshop you are working with RGB (red, green, blue) color space, so an 8-bit depth file contains 24 bits, 8 for each color. Don't let that confuse you, because Photoshop and other high dynamic range (HDR) image merge programs usually only deal with 8, 16, and 32 bit depths, which are measured in bit depth/channel (Figure 8.1).

Figure 8.1 Navigating to the bit depth of images in Photoshop.

In a camera, the color bit depth is affected by the size and resolution of the sensor. The more color pixels you have, the more color depth that will be recorded. When you make an HDR photo, you are increasing the color depth because you are adding tones from three or more different exposures. Most HDR algorithms process those three photos into one 32 bits/channel image.

For an image to be HDR, it must have a 32-bit depth because that is the only file type that can hold all the information about the image. For the best-looking 8-bit images that replicate HDR, you should work in 32 bits/channel throughout your workflow, which means that after you merge your photos using HDR software, you should wait to change your image to a lower bit depth. One way you can do this is to save the 32-bit depth image that has been merged as a TIFF file before you move on to any other steps. Note that the 32-bit file can be up to 300 MB, which takes up a lot of space on your hard drive. At the end of the work flow you can adjust the levels or curves in Photoshop and then convert the file to 8 bit using Image > Mode > 8 bits/channel.

When you do go to convert, you're given a variety of methods. Most photographers choose Local Adaptation because it's the only choice that fine-tunes your image pixel by pixel, which makes a better faux HDR image. You'll get step by step directions about what bit depths in Photoshop and Photomatix to use in Chapter 31, "Photoshop CS5 and CS6 (HDR Pro and Working with Settings)," and Chapter 34, "Photomatix Options."

CHAPTER 9
Tonality

Tonality is the number of tones in an image—any image. It's easy to confuse the terms tone, color, hue, and shade. As you know, colors can be changed by adding black or white. When you add white, it's a pastel; add black, and it's a shade; add nothing, and it's a hue; add both black and white, and you have a tone. In high dynamic range (HDR) photos of some scenes, there are many more tones than in a photo taken with one exposure of the same scene.

HDR toning is when you take an image—any image—and tone it using a toning tool such as the HDR Toning option in Photoshop CS5 and CS6 (Image > Adjustments > HDR Toning). You can tone-map any image you want in Photoshop to make it look like HDR, but it works best in image that have little or no clipping. A tone-mapped image isn't possible with a 32-bit depth images because today's monitors can't handle that much information. (I'll get into that later in the book.) You have to take it down to 16 bits for tone mapping, making it a simulated HDR image, not a true one.

Tone mapping is best done to HDR photos when at the HDR bit-depth (32 bits/channel). The HDR software you are using will automatically give you tone mapping sliders and options. When you're using the 32 bit/channels, after merging two or more photos of different exposures, you are including a wider range of tones that haven't been reduced through channel changing, thus the really cool effect you get.

To tone-map any image in Photoshop, navigate to Image > Adjustments > HDR Toning (Figure 9.1). Tone mapping uses a complex algorithm to calculate tonal changes in an image to make it look like an HDR photograph. Figure 9.2 shows a tone-mapped, single exposure image. Chapter 32, "Simulating HDR Using a Single Photo," covers how you can tone-map a single image using this tool.

Tonality is a misunderstood subject in HDR photography. Objects that reflect a lot of light under good light conditions are bound to have more tonality than those colors that reflect little light under low light conditions. Tone mapping is not HDR; it simply uses an algorithm to change color locally on a low dynamic image instead of changing the color of the entire image. Many photography aficionados look at an HDR and find its tonality offensive—fake to be more exact. Although not everyone feels this way, the group that does is rather vocal on the Internet.

Figure 9.1 Photoshop CS5 and CS6 have a tone-mapping feature.

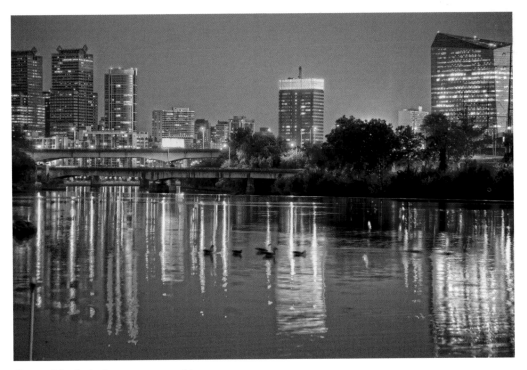

Figure 9.2 A single tone-mapped image.

PART III

Cameras and Accessories for Shooting HDR

Cameras, Sensors, and Resolution

I f you are looking for a camera to shoot high dynamic range (HDR) and produce the sharpest images, you'll want to consider the camera make and model. Cameras are sold in the following categories: point-and-shoot, digital Single Lens Reflex (dSLR), mirrorless, and in-camera HDR capable cameras. Many mobile devices have an HDR function, where three images are merged to add details to the shadows and highlights of an image. iPhone 4 has a built-in HDR function, and Android has an app to merge photos.

HDR-capable cameras can be divided into two categories. In the first category, the HDR is processed in the camera and you don't have to worry about controlling anything. In the other category, which doesn't process in-camera, you have full control, not only with a camera, but with image processing software that you need to create the HDR image.

Finally, there are a few camera features and additional pieces of equipment that will make your HDR shot have the "Wow" factor: a high frames per second shot count, a fast lens, a timer or cable release, and the most important of all: a tripod.

The first setting that you'll most likely want if you've started shooting HDR is Auto Exposure Bracketing (AEB). Start shooting by the first frame for the HDR set by setting the Exposure Compensation to a value and taking a shot, and then moving your camera to look at the setting so you can change it to another value for the second shot, and so on. HDR shots need to be taken in the exact same spot a moment after you take the first shot. When you move your camera to change the exposure compensation the second time and then reshoot, your estimation of the location of the first shot is unlikely to be as accurate as if the images were taken on a level surface or with a tripod. Under these circumstances, you need to use AEB. Just to refresh your memory, AEB is when you set your camera to take a series of several images, underexposing some of them, shooting one at normal exposure, and overexposing what's left by holding down your shutter during the series of shots your camera is set for. Depending on the camera model, you can shoot 3, 5, or 7 exposures automatically. For example, my Canon D5 can take three shots at three different exposures, which I can set to various stop increments.

HDR photography requires that your camera have four important modes. Those modes are usually called Av or A (aperture priority), Tv (time value), S (shutter speed priority), and M (manual control). At the very least, your camera should have Av and S settings to take an HDR shot. Av is the setting you will use most for HDR photography. These modes are discussed in the sidebar "Aperture What?" in Chapter 11, "Camera Phones."

One additional setting, Exposure Compensation, over- and underexposes your shots according to the number of stops at which you set it (see Chapter 3, "Dynamic Range in Digital Photography").

At a minimum, the camera should allow you to manually change the exposure settings with relative ease. This will allow a camera mounted on a tripod to shoot HDR images. Trying to hand-hold and shoot an HDR setting at a different exposure compensation for each shot is pretty much impossible because you have to fumble through the settings and move your camera down from your eye if you're using a dSLR in Viewfinder mode. This makes getting three or more shots in the same location extremely difficult. That's where AEB comes in. (See Chapter 21, "Auto Exposure Bracketing.")

Now that you know what's necessary to have in a camera for HDR photography, there are a couple of things that you don't absolutely need but that are nice to have, especially if you want to shoot HDR while hand-holding your camera. The first is physically inside the camera—the sensor size and resolution. The other is Auto Exposure Bracketing, which is usually found in the menu on the LCD screen and is discussed in Chapter 3.

Sensor size makes a difference when shooting in HDR, whereas sensor type (CCD or CMOS) doesn't. If you have a point-and-shoot camera, you're more than likely to have a small sensor. If you have a dSLR camera, you will have a sensor around 5 times larger than one on the point-and-shoot. A larger sensor captures finer details that will come out much sharper with a dSLR camera, especially when viewed at 100 percent resolution.

Figure 10.1 Image at 100 percent resolution taken with a 5 Mp point-and-shoot camera.

Figure 10.2 Image at 100 percent resolution taken with an 8 Mp dSLR camera.

You can see the difference in Figures 10.1 and 10.2. Figure 10.1 was taken with a point-and-shoot (Kodak CX7530 zoom digital camera 1920 × 2560) camera that has a sensor of about 4 × 5 mm. Figure 10.2 was taken with a dSLR (Canon 350D) 3456 × 2304 camera that has a 22.2 × 14.8 mm sensor. Both are shown blown up to 100 percent resolution on a computer screen. As you can see, the image taken with the dSLR camera is much sharper and has less noise than the one with a point-and-shoot, while the one taken with the compact camera is very noisy.

N O T E
HDR photos won't make sharper photos if the images from which they are combined aren't sharp themselves.

In the recent past, camera manufacturers have put point-and-shoot cameras on the market that do have bigger sensors. They are often called mirrorless cameras because they act like a dSLR (in that they take sharp images and have interchangeable lenses) without mirrors.

It's best to get out of your mind that higher resolution (number of pixels) means better image; it helps you obtain a sharper image, but it's not everything. The best image comes when your camera has a larger sensor. The larger the sensor is, the bigger the pixels, and the bigger the pixels, the more information the sensor can get, including details in the highlights and shadows.

The optimal sensor size is a full-frame sensor, which is about the same size as a 35 mm film negative. Lower-priced models of dSLRs have sensors smaller than full frames but still much larger than the sensors of the point-and-shoots. The Canon 50D, Rebel XSi, and Nikon DX have these types of sensors. Also, many mirrorless cameras have sensors about this size. These sensors are referred to as APS-C and are about 25 × 15 mm, although some are a little bigger and others are a little smaller.

Some mirrorless cameras, called the micro four thirds cameras, have a sensor size of 18 × 13.5 mm, which produces an image with different proportions than most dSLRs (4:3). That proportion (called aspect ratio) is the same as those sensors in most point-and-shoot cameras. All dSLRs have a 3:2 aspect ratio.

CHAPTER 11
Camera Phones

Without a doubt, the camera phone is ubiquitous. Using it for high dynamic range (HDR) is encouraged of late—the iPhone 4S and MyTouch have an HDR mode. (See Chapter 14, "In-Camera HDR Processing.") Using a camera phone for handheld HDR shots is virtually impossible today for a couple of reasons. There is no way to shoot three shots of different exposures other than the recently developed HDR mode in the iPhone 4S and the MyTouch 4G. As of the writing of this book, no cell phones have an Aperture Priority mode that lets you keep the aperture the same and change the shutter speed to get three shots of different exposures.

If you look at Chapter 10, "Cameras, Sensors, and Resolution," you'll see that you can make a tone-mapped image with an HDR processing program. To do this, you have to adjust the exposure in Adobe Camera Raw (ACR), Photoshop, or Elements, creating two additional shots from the one photo—one where the exposure has been increased and another where it has been decreased. See Figures 11.1 through 11.3.

Figure 11.1 Underexposed version of iPhone photo re-created with ACR from normally exposed iPhone photo.

Figure 11.2 iPhone photo from which two other photos were made in ACR.

Figure 11.3 Overexposed version of iPhone photo re-created with ACR from nor-mally exposed iPhone photo.

APERTURE WHAT?

Aperture is a value that lets you know *how much* light is being let into the camera to strike the sensor. The camera lens has a small hole that lets in light when the shutter is released. The size of the hole varies; that variation is measured by a number that is called the aperture. Although there are no aperture controls as an option on cell phones, there are apps that you can use to control the exposure so you can take images at varied exposures. One of these apps is PhotoGenie, which contains an Exposure slider. You can shoot three shots: one at normal exposure, one with the slider dragged to the right for overexposure, and one dragged to the left for underexposure. After that you can merge them in an HDR program.

Unless you have the cell phone on a stable surface or use a cell phone tripod, you'll get camera shake. This can be alleviated fairly well with the deghosting (elimination of movement blur) tool in the HDR programs.

On mirrorless, digital Single Lens Reflex (dSLR), and some point-and-shoot cameras, the aperture priority setting is commonly used for taking HDR photo sets. Apertures in Aperture Priority mode should be set to the same value for each shot in the set. Exposures are changed by adjusting the Exposure Compensation. On Canon cameras, the aperture is indicated by Av on the top dial of the camera; on Nikon dSLRs, it's just A. It gets confusing because the values you see on your camera—4.0, 4.5, 5.0, 5.6, 6.3, 7.1, 8, 9, 10, 11, 13, 14, 16, 18, 20, 22 (from a dSLR Canon 5D)—don't indicate the value of the aperture width. The inverse of the values—1/4, 1/4.5, 1/5, 1/5.6, and so on...—does, however. Most of the time these values are written as f/4, f/4.5, f/5, and the like. You don't have to think too hard that, instead of the values going up, they go down; that is, think of 4 as the largest opening and 22 as the smallest.

Shutter speed (*how long* the light is striking the sensor) is a tad bit more complex. It is measured in seconds and fractions of a second. If you're well versed in fractions, it won't be a problem; if not, you can figure it out fairly quickly. The values are given as (on a 5D)—8000, 6400, 5000, 4000...800, 640, 500...80, 60, 50...20, 15, 13...8, 6, 5, 4, 0"3, 0"5...0"8, 1", 1"3, 1"6, 2", 2"5, 3"2, 4"...30". These represent the following values: 1/8000, 1/6400, 1/5000, 1/4000...1/800, 1/640, 1/500...1/80, 1/60, 1/50...1/20, 1/15, 1/13...1/8, 1/6, 1/5, 1/4, 0"3/10, 0"5/10...0"8/10, 1", 1"3/10, 1"6/10, 2", 2"5/10, 3"2/10, 4"...30". So the fastest shutter speed is 1/8000 of a second, and the slowest is 30 seconds, which means the shutter opens and closes very quickly at high speeds and more slowly at slow speeds.

You might ask what this has to do with HDR photography. Well, the answer is a lot. You have a choice of three modes when shooting HDR: Aperture Priority, Shutter Priority, and Manual. Each has a purpose in HDR photography that depends on how much light you have. Under most light circumstances, you can use the Aperture Priority, but there are instances, mostly at night, where you need to use Shutter Priority mode or Manual mode. The purpose and technique is discussed in Chapter 18, "Aperture and Shutter Priority Mode," and Chapter 19, "Manual Mode."

CHAPTER 12
Point-and-Shoot Cameras

With some point-and-shoot cameras, like the Canon S95 (Figure 12.1), it's all automatic. At the very most, you'll have many scene settings, which control multiple settings at once but don't leave you with enough control over the exposure to take high dynamic range (HDR) shots. Other point-and-shoots do come with aperture, shutter speed, manual modes, and exposure compensation settings. Some also come with a high continuous picture-taking rate and with Auto Exposure Bracketing (AEB).

Figure 12.1 Canon S95 point-and-shoot with HDR mode.

If knowing about aperture and shutter speed sounds too difficult to understand, I explain it briefly and simply in the sidebar "Aperture What?" in Chapter 11, "Camera Phones." If you already know what those values are, you can skip that.

TIPS FOR POINT-AND-SHOOT SHOOTERS

When you are aware of aperture and shutter speed and want to take HDR photos, you can purchase a point-and-shoot camera that has those settings. There is one drawback to using a point-and-shoot camera for HDR photographs: it's likely that you won't have a dial to change when you increase or decrease your exposure compensation. What this means is you'll take a little longer because you first have to locate Aperture Priority mode on your camera's menu and set it; then you have to take the shots, changing the exposure compensation each time you shoot. It pays to get to know your camera well so you can locate these settings quickly, because HDR photography requires that you have as little time as possible between shots.

When you buy a point-and-shoot camera, you should pay close attention to shutter lag times, or the time it takes the camera to take a shot and process it after you press the shutter release button. In recent model cameras, shutter lag times have dropped precipitously, so if you have an older model, consider upgrading to a newer version of that model if you like it. Some of the newer point-and-shoot models have hardly any shutter lag. A camera with a shutter lag time less than three-tenths of a second is best for HDR shots. Finally, when you are taking a shot while waiting for the right moment with a point-and-shoot, you can reduce shutter lag time by starting to hold the shutter halfway down well before you take the shot to focus the camera on what you're shooting and then shooting when you're ready.

One point-and-shoot camera that has Raw format, manual modes, and exposure compensation settings, the Sony DSC TX10, has a 16.2 Mp 6.17 3 4.55 mm sensor. That's small to say the least, and it won't give you the best quality HDR image at 100 percent resolution.

Point-and-shoot models good for shooting HDR sets include the Canon G-series 12, Fuji Fine Pix HS10, Fuji FinePix S9600, Fuji FinePix F550EXR (with low shutter lag time), and Nikon P7000. They're good models for shooting in HDR for a couple of reasons. The first is that these cameras shoot in Raw. They also have both AEB and exposure compensation settings and an incredible 4.2 frame/second shooting rate. The only drawback is their sensor size, 7.49 3 5.52 mm, which is in line with most high-end point-and-shoots. The big plus is that they are cheaper than mirrorless and digital Single Lens Reflex (dSLR) cameras. The G12 also has a new feature that earlier models did not have: an HDR shooting mode. You'll read more about that in Chapter 14, "In-Camera HDR Processing."

Finally, there is the Canon S95 (refer to Figure 12.1), a point-and-shoot camera with an HDR mode. It automatically takes a series of shots and then merges them in-camera to make an HDR image.

Cameras with Large Sensors—dSLR and Mirrorless

With a mirror and a pentaprism inside to reflect what the lens sees so you can view it in a viewfinder, a digital Single Lens Reflex (dSLR) camera, as shown in Figure 13.1, enables you to see directly through it before you take your image. That's in contrast to a point-and-shoot and mirrorless camera, which depends on a system whereby the sensor sees the image and a video mechanism displays what the sensor sees onto an LCD screen. This means that the mirrors block the sensor when you're not taking a picture and are moved when you open the shutter (by pressing down the shutter release button all the way).

Figure 13.1 Canon's Rebel T3i, like other digital Single Lens Reflex (dSLR) cameras, shoots in Raw and has an Auto Exposure Bracketing (AEB) function.

dSLR cameras shoot higher-quality images for a couple of reasons. All dSLR cameras come with the necessary settings for high dynamic range (HDR): Aperture Priority, Shutter Priority, Exposure Compensation, and AEB control.

As I mentioned in Chapter 10, "Cameras, Sensors, and Resolution," dSLR sensors are much bigger than those found on the point-and-shoots, they shoot faster than most point-and-shoots, you can use different lenses, and what you see through the viewfinder is what is actually in front of you. (For this reason, it's referred to as an optical viewfinder.) Contrast that with a mirrorless and point-and-shoot model, which is recorded and is unlikely to handle any type of motion in your photo, softening it significantly with more motion blur than a dSLR with a viewfinder. This is referred to as image latency, which is when you follow subjects or a background that is moving rapidly. Finally, dSLR cameras have better shutter lag times (the time it takes for a camera to take a picture after the shutter release button is pressed all the way down) than the point-and-shoot models. dSLRs run shutter lag time: from 0.1 sec to 0.14 sec.

To be sure, dSLR cameras aren't perfect. Besides camera shake from unsteady hands, the movement of the mirrors can cause slight softness in photos, as does the action of pressing down the shutter release button when you take a shot, both of which can spoil an otherwise perfect HDR shot.

NOTE

You can usually get a sharp shot with a dSLR camera if the shutter speed is less than the inverse of the focal length of the lens you've used to shoot your image. For example, if your focal length is 60 mm, the fastest shutter speed you can get by with for a sharp shot would have to be taken at a shutter speed less than 1/60 second.

Some entry-level dSLRs, such as the Canon 1000D (Rebel XS) and Canon 1100D (Rebel T3), have limited AEB shooting; the maximum step increment is only 1 stop of exposure compensation, which makes it possible to get only 3 shots that have a maximum range of 2 (+2, 0, –2).

Recently camera manufacturers have come up with dSLR models that have both a viewfinder and what is called a live view, which enables you to take a picture by looking through the viewfinder or holding up the camera while looking at the LCD screen. Taking a shot with a viewfinder on a dSLR camera works electronically, the same way it does on point-and-shoot and mirrorless cameras. The viewfinder works as it always has with a prism and mirrors, as described at the beginning of this chapter.

Models that have both a live view and a viewfinder are especially good if you're used to shooting with live view (from your point-and-shoot days) or if you stretch your arms out to take a shot. The caveat about this is that the mirror, which is up in this mode so it doesn't block the sensor and can give you live view, has to drop to focus the camera and then raise up again to take the picture. That causes a momentary blackout in the live view.

dSLR models such as the Sony Alpha A330, Nikon D5100, Canon Rebel T3i, and Pentax K-r all have live view screens. All models have a good AEB function, shoot in Raw, and have fairly fast frames per second. All have the same size sensor, too: the APS-C (see Chapter 10).

If you consider dSLR cameras with full-frame sensors, your eyes should definitely be drawn to the Nikon D700 and the Canon 5D Mark II. Both are professional-grade cameras that many photographers use. Both shoot video and offer live view for taking pictures. Finally, both are in the mid-price range for dSLR cameras ($2,000–3,000) and the least expensive of full-frame sensor models. A higher-end model exists for both manufacturers—the Nikon D3X and the Canon 1D—each several thousand dollars pricier than the lower-end models that give you about 80 percent of the options of the highest-cost models.

Alternatives do exist for people who don't want cameras from the cream-of-the-crop manufacturers, Nikon and Canon. Sony, Olympus, and Pentax all make entry-level dSLR models. Sony Alpha A350 SLR (14.2 Mp, 23.6 × 15.8 mm sensor size, 3 frames/second with 0.3 or 0.7 EV AEB) can be used with both Sony and Minolta lenses, so you don't need to be concerned with not having enough lenses to use. The Olympus E5 (12 Mp, 13.0 × 17.3 sensor size, 3 frames with .7EV or 1.0EV) uses four-thirds technology so that images aren't the traditional 2:3 like most dSLR cameras, but instead, are 4:3, making them more inline with the size most point-and-shoot models produce. The E5 also is compatible with a variety of Zuiko Digital lenses. Finally, the Pentax K-5 (16.3 Mp, 23.4 × 15.6 sensor size, up to 5 frames AEB) uses a variety of Pentax lenses and includes an HDR mode.

Mirrorless cameras are the most recent development in digital photography. They have big sensors (but not full frame), come without mirrors, and have interchangeable lenses. The caveat of these cameras is the limited number of interchangeable lenses that are available for each model, which are far fewer than those offered with traditional dSLR cameras. That will change over time.

At the top of the line are the handmade Leica cameras with full-size sensors. These cameras, or Rangefinders, don't use an electronic viewfinder; instead, they use a system of merging two images into one as you focus on the object. You never look through the lens. Leica Rangefinder cameras are among the finest in the world and are very expensive, taking better photographs than their dSLR and other mirrorless counterparts.

Like Rangefinder cameras, other mirrorless cameras, sometimes referred to as Micro Four Thirds cameras, also have smaller lenses because the flange-back distance (distance from a point inside the camera to the back of the lens) is half the length of that in a dSLR, the result of having no mirrors. Panasonic, Olympus, Sony, and Samsung make the cameras. Nikon came up with two—the J1 and V1—but these are the oddballs of the lot; their sensor sizes (13.2 × 8.8 mm) are smaller than other models, a size that is between the sensor size of a point-and-shoot and a dSLR. Aside from the smaller sensor, which is quite adequate in terms of picking up some details in highlights and shadows, the cameras have no AEB.

Like dSLR cameras, just how good each model is for HDR depends on the make and model. Two options that you want to have, which most do, are AEB and fast shooting (high number of frames/second), which were discussed in Chapter 21, "Auto Exposure Bracketing." All models have exposure compensation and AEB settings except the Nikon J1 and V1.

Sony has a high-end 24 Mp NEX-7 camera, a coveted model for professionals because of its small body and interchangeable lenses. The models of other mirrorless cameras and their specs include the following:

- **Sony Alpha NEX-5**—14.2 Mp, 23.4 × 15.6 mm sensor size, 3 frames with 0.7 AEB, also has HDR mode

- **Panasonic Lumix DMC G10**—12.1 Mp, 17.3 × 13 mm sensor, 3, 5, 7 frames/second 1/3 or 2/3, +/–2.0 AEB

- **Olympus PEN E-PL2**—12 Mp, 17.3 × 13.0 mm sensor, 3 frames, 2, 4, 6 AEB

THE TIMER AND CABLE RELEASE

A cable release is a camera accessory that you connect to your camera with a cable that has a shutter release button at the end of it so that so you don't have to put your hands on the camera when you are shooting. Most dSLR cameras have a port that supports a shutter release cable. The cable and switch of a cable release are sometimes sold separately.

A cable release is not mandatory for an HDR shot, but it gives you more room to work. After you are finished setting your camera, you don't have to be near it when you are taking a shot. It works particularly well when you are doing three or more shots without using AEB, because you'll only touch the camera to change the exposure compensation rather than doing that and then pushing down on it to take a picture, as you'll do with the cable release.

You can also get wireless cable releases, often called remote controls. They work up to 15 feet away from the camera. The Canon RC6 works on most Canon dSLR models and contains a lock to keep the shutter open for long exposures. If you prefer a cord, Canon also offers the RS60 E3, a wired device that connects directly to the Canon camera and works just like the shutter release on your camera in that you press it halfway down to auto-focus and all the way down to shoot. All cable releases are under $25.

The Nikon equivalent of the Canon wireless model is the Nikon ML-L3. As far as a wired release is concerned, Nikon makes this a bit complex in that you need to buy both a cable (Nikon ML-L3) and a switch. Many companies make switches that you can use with a Nikon cable.

To be sure, you don't have to use a timer. With HDR photography, a timer isn't the best solution. When you use a timer, you set your camera to take a picture a number of seconds after you've pressed the shutter release. On most cameras, the time between pressing the shutter release and the camera shooting is 2 or 10 seconds.

If you do end up using the timer, make sure you have found in your manual how to access and use it. There's nothing more annoying than pressing all the buttons on your camera looking for one of its features.

In-Camera HDR Processing

You might already be a bit familiar with cameras that can produce in-camera high dynamic range (HDR) shots. I've mentioned three in previous chapters: the G12, Sony NEX-5/7, and Pentax K-5. The first one is a point-and-shoot, and the last two are mirrorless. Let's look at those first to get a feel for what in-camera HDR processing is all about.

The Sony NEX-7 (see Figure 14.1) is the highest-end mirrorless camera you can get. It's *the* camera to replace many digital Single Lens Reflex (dSLR) models because of its size. The cost is about $1,350 with kit lens and includes a slew of options:

- An in-camera HDR.

- 24.3 Mp and 23.5 × 15.6 mm sensor (the same size sensor as the lower-end model, the NEX 5).

- Traditional hot shoe, which is the connection slot for an external flash unit. (Other NEX cameras have an accessory port, shared with an external viewfinder.)

- A built-in viewfinder. (You have to buy this as an attachment with other NEX cameras.)

The NEX-7 has a mode—Dynamic Range Optimizer—to pull the details out of shadows and highlights and HDR mode. It also has a choice of multiple shot modes for taking HDR photos, which are processed in camera.

Figure 14.1 The Sony NEX 7 is sometimes used as a dSLR replacement.

Pluses and minuses exist for the NEX cameras. For taking in-camera HDR shots, there is the auto-HDR mode, where you can take three multiple shots at +1/–1 to +6/–6—quite a range. This is strange since the main caveat of this camera is that the Auto Exposure Bracketing (AEB) increment is only a tiny .7 EV. Another drawback of the NEX cameras is that the Auto-HDR function takes only JPEG photos. Keep in mind, also, that no matter how good the in-camera HDR is, you'll get a better image when you manipulate merged multiexposure photographs using software like Photomatix (see Chapter 33, "Photomatix—A Quick Run-Through").

An even smaller sensor and camera is the Canon PowerShot G12 (10 Mp, 7.49 × 5.52 mm sensor), which is great for images you want to put on the Internet. Because the sensor is small, there's likely to be pixelization if you want to blow up a picture and hang it on your wall. One more PowerShot—the S95 (10 M, 7.49 × 5.52 mm sensor)—also has an HDR mode that takes three shots automatically and combines them. Both cameras shoot in Camera Raw.

On the dSLR side, the Nikon D5100 (16.2 Mp, 23.6 × 15.7 mm sensor), shown in Figure 14.2, has an easy-to-use HDR mode in the menu that you turn on. You then choose Smoothing (high, medium, low with an increased surreal effect on the low end) and EV Increment and set the timer to take three consecutive shots. You can choose to have your shots taken 1, 2, or 3 EV apart when the camera is set to matrix metering. All other metering will only take shots that are 2 EV apart. One drawback of this camera's option is that the HDR photo is taken in JPEG format.

Figure 14.2 Nikon D5100 is an entry-level dSLR with in-camera HDR.

Finally, there's the ubiquitous iPhone 4, which also has an HDR option. When you tap the mode "on," it takes three consecutive pictures just as many of its non-phone competitors do. After you shoot, the camera processes the images—both HDR and normal shots—in about 5 seconds and places them in the Camera Roll, displaying the HDR shot on your screen. One drawback of the phone: it tends to desaturate images, a problem that can be solved with apps like Photoshop Express and PhotoForge.

The iPhone 4 HDR option works well with landscapes and still lifes, but it isn't great for images of human subjects. It's subject to turning white into gray and making flesh tones dull—so much so that the subjects look anemic.

CHAPTER 15
Lenses

At this point in the consideration-of-equipment process, you might be thinking about replacing the lens you got with your digital Single Lens Reflex (dSLR) (usually an 18–55 mm kit lens) or upgrading to a dSLR or mirrorless model.

You'll have no problems shooting high dynamic range (HDR) with your kit lens. What the camera company gives you with your camera is pretty good. You get sharp pictures within a reasonable range of focal lengths, which are the distances from the optical center of a lens to the image plane when the lens is focused to infinity—in other words, how far and how much your lens is able to see measured in millimeters on the lens barrel.

You can go two routes when considering upgrading lenses: sticking with photography as a hobby or going serious amateur/professional. If you're the former, you'll probably be fine with an entry-level dSLR for a long time. If you're the latter, you'll eventually upgrade to a full-size sensor.

If you're a hobbyist photographer, the first thing you want to recognize when you purchase an entry-level dSLR camera is that the sensor is smaller than full size (24 × 36 mm), yet you have to keep that size in mind because it is the standard when talking about focal lengths. Cameras that have any sensor smaller than full size come with a set of numbers called "35 mm equivalent." Those are the numbers given to you on the lens. If you have a smaller sensor, there is a conversion (crop) factor (usually about 1.5 or 1.6 depending on camera model) that you have to figure when considering what the actual focal length of the lens is. Any numbers you get in terms of 35 mm equivalent, you must multiply by the crop factor to get the actual focal length of the lens. For example, a Canon EF 24–105/4L IS (24–105 mm focal length with a full-size sensor) will have a 35 mm equivalent of 38 to 168 mm on a Rebel T3i because the crop factor is 1.6, meaning that each focal length of the 35 mm equivalent was multiplied by 1.6 because Canon entry-level cameras have a (smaller) sensor size requiring that crop factor.

> **N O T E**
>
> Note that Nikon entry-level cameras have a crop factor of 1.5, which means that their sensors are a bit larger than those on a Canon model.

By now you're probably wondering what kind of lens or lenses to upgrade to. Recall that the focal lengths listed on the lens will in fact be bigger for the entry-level dSLR cameras (1.5X for the Nikon and 1.6X for the Canon). For the hobbyist, the following would be good as general-purpose lens replacements and wouldn't cost more than a few hundred dollars for each lens:

- Canon's EF-S 18–200 mm f3.5–5.6 IS is a great lens if you like photographing birds and landscapes, but it's not compatible with full-frame cameras.
- Nikon Zoom-Nikkor Zoom lens 18–105 mm f3.5–5.6 has a bit more telephoto than the kit lens, but it isn't of much better quality.
- Two Nikon lenses together: the Nikon 18–200 mm f3.5–5.6 G IF-ED AF-S DX VR Zoom-Nikkor lens for telephoto and the 12–24 mm lens for wide angle.

THE FAST LENS

You'll find an f-number or f-number range on a lens. If it's only one number, it means that f-number stays the same throughout all focal lengths. If it's a range of numbers, the f-stops change as you change focal lengths. The numbers are the range of focal lengths the lens shoots at.

Lenses that open to wide apertures are considered fast lenses because when the apertures are open very wide, the shutter speed has to be faster so the shot takes less time. A lens with a minimum f-stop of 2.8 can use a faster shutter speed than a lens with a minimum f-stop of 5.6 for the same exposure. With a fast lens, it's much easier to freeze subjects when they are moving quickly and take decent pictures in low light.

These types of lenses are often used in sports photography because they can catch subjects in action. They're also adequate for HDR provided the subject/object isn't moving. They work well when you want to zoom in up-close on a subject that is inaccessible from the spot you are taking the picture from, keeping nonmoving objects sharp, as shown with the billboard part of the image in Figure 15.1; however, they are susceptible to ghosting when the subject is moving as shown with the main subject in the figure.

Figure 15.1 Moving subjects/objects can cause ghosting, which you can usually remove with HDR software.

The Canon EF 24–105/4L IS, which has a 35 mm equivalent of 38 to 168 mm on a Rebel T3i, is one of the best in the industry, but it costs about $1,000. It's a great general-purpose lens. For the gonna-be-pro, it'll cost you more, but the lens can last a lifetime.

For a telephoto, consider the Canon EF 70–200 mm f2.8L IS II USM Telephoto zoom lens, which is fast. (It freezes action at wide aperture; 2.8 throughout the focal lengths of the entire zoom is a very wide aperture.) It's a little over $1,000, so it's rather expensive. This L series lens is one of Canon's finest professional grade lenses and works well with the T3i. It's one you'll be able to use when you switch to a full-frame sensor digital camera like the 5D Mark II.

Tripods

There are a slew of choices when it comes to buying a tripod. The first thing you want to consider is the weight of your camera. You don't want to get a tripod that can't handle your camera.

Bringing your camera along with its largest lens while shopping for a tripod is the best way to get a tripod you like and that you can use easily. When buying a tripod online, look at the weight of your camera and buy a tripod that can support it. If you don't know the weight of your camera, weigh it with the heaviest lens it takes so you can cover the camera when it is attached to any of your lenses.

If the tripod you are interested in can handle your camera, consider the weight of the tripod itself. Remember that you are the one who is going to be lugging this tripod around. I prefer a lightweight standard tripod because I want the job of steadying the camera done right, so I carry one made of carbon fiber. To be sure, it's big, but it does the trick, and it isn't so bad once you get used to having it with you all the time. My tripod, shown in Figure 16.1, has gone with me to places as far away as Romania. I've traveled with it by putting it in a large wheeled bag with my clothing. It's been on trains, planes, busses, and subways.

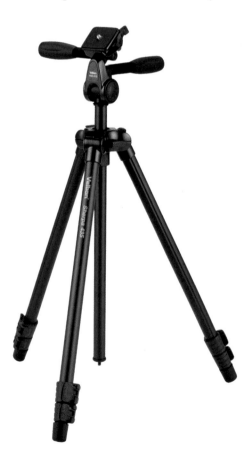

Figure 16.1 Velbon tripod, costing $100–200, designed for digital Single Lens Reflex (dSLR) camera.

You'll have to make two considerations when buying your tripod: figuring out how much you want to spend, and deciding how portable, light, and sturdy you want it to be. Be aware that light tripods that can handle heavy cameras are going to be expensive. Somewhere along the line, you'll have to make compromises on the weight of the tripod to get the tripod you want with the money you have.

Tripods are often sold with legs and head together. However, you can also purchase the two separately. If you're just beginning to shoot in high dynamic range (HDR), buying them together is a simpler process.

One tripod that I have been satisfied with is the pan-and-tilt Velbon PH 250B. If you go with a ball head, you'll pay more money. The only drawback is that there is no bubble level to make sure your shots aren't shot with an angle. It also doesn't tilt upward far enough. However, I like this tripod because it is sturdy, can handle my Canon 5D with a large 70–200 mm lens, and has knobs that operate smoothly. If you go on the cheap, you're not likely to get many of these features, leaving you with a plastic, hard-to-maneuver piece that you'll end up replacing in less than a year.

Some people like a quick release plate because it makes it easier to attach the camera to the tripod. However, I don't like that feature; it's too easy to misplace the plate because it is a separate, detachable piece of the tripod.

If you consider spending $100–200, you can get a suitable tripod for all types of cameras. Here are the things you should look for when buying a tripod:

- Handles cameras up to 7 lbs
- Sturdy enough so it won't blow over in a strong wind
- Smooth handling from pulling out and locking legs to panning and tilting
- Lightweight
- Bubble level

In terms of makes and models, there are some very good tripods supporting cameras up to 7 lbs (up to 11, in most cases) in the $100–150 range. They include a Manfrotto MK 394 PD Photo Kit QR with a ball head, a Manfrotto 294 aluminum 3-section tripod with a W/QR ball head, a Cullmann Magnesit 522 aluminum one with a 3-way head, and a Smith-Victor Propod IV aluminum one with Pro-4 3-way pan and tilt.

PART IV

Camera Settings

CHAPTER 17
Setting Up

Setting up in the field depends on the kind of photography you are shooting. It can range from a quick candid shot using Auto Exposure Bracketing (AEB) to a time-consuming manual shot with a tripod using the camera's timer or cable release at dawn or dusk. The next sidebar, "Getting the Gear Ready," lets you know what you need to do to get ready the night before.

GETTING THE GEAR READY

Generally, if I'm going to be out all day, I get things ready the night before (see Figure 17.1). That's the time I check what the weather will be on the shooting day, recharge my batteries, and gather everything together except my camera. Just remember to put the battery back into the camera after recharging it.

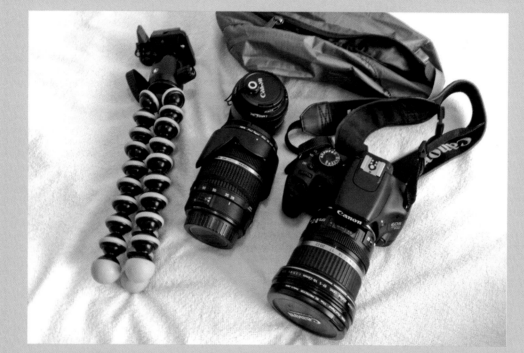

Figure 17.1 Equipment set out the night before a shoot. Courtesy of comicpie at www.flickr.com/photos/patio/.

The equipment I put aside the night before includes the tripod, a camera bag (or backpack), a small flashlight, a lens cleaning cloth, lenses, a charged spare battery, an extra memory disk, and a cable release.

Before bed (or upon waking up), I load the battery into the camera and check that the camera is set according to what the light will be when I leave. I check my ISO speed first, setting it to ISO 100 or 200, because my biggest mistakes have occurred when I haven't reset my ISO from the night before. There's nothing worse than shooting a high dynamic range (HDR) photo at ISO 1000 at 9 a.m. Next, I set the AEB.

I put the camera around my neck, fill up my backpack with the lenses and accessories, and hit the road.

Before you shoot candidly using AEB, you need to do the following:

1. Turn your camera on and take your lens cap off. A few photographers leave the cap at home and use a UV filter or lens hood. If you want your lens to stay in shape, always have the lens cap with you.

NOTE

You can use your lens cap as a brace to still your camera by holding it next to the camera (on the right) to make it steady. See Figure 17.2.

Figure 17.2 Stabilize your camera by holding your lens cap next to it.

2. Set ISO to 400. This helps keep the overexposed image sharp, because it has the longest shutter speed.

3. Set the AEB. (See Chapter 21, "Auto Exposure Bracketing.") If it's a cloudy winter day, set the underexposure to +1/3 to +1. In other words, set the AEB to +2, 0, –2 and then increase the exposure compensation 1/3 to 1 stop (all the AEB settings will move that amount), depending on the time of day.

4. When you find a subject/object/scene to shoot, stop walking and stand still for a second. This decreases the likelihood of blur from camera movement.

5. Snap the image, making sure you hold down the shutter release button until the camera stops shooting.

> **NOTE**
>
> Using a lens hood (a plastic element attached to the end of your lens, extending a few inches beyond the lens) can keep light coming in from the sides of your camera and produce enhanced color in your shot.

Shooting with a tripod doesn't require that you use AEB, although you can if you want. The advantage of not using AEB is that you can shoot at any exposure values you want and merge the shots taken at different exposures to get an HDR image (see Figure 17.3). HDR is a developing art. You don't have to follow the rules and make your exposures increase/decrease in equal amounts to get a good HDR shot. Many times during a twilight shoot (the time between dawn and sunrise or between sunset and dusk) using Manual mode, you won't have time to figure out equal increments in stops when changing the shutter speed. All you can do is estimate each shutter speed to shoot at. An example of using different increments in shutter speeds is illustrated in Chapter 25, "Night Landscapes."

Figure 17.3 Handheld HDR from three AEB shots.

Here are the steps for setting up a shoot with a tripod:

1. Gather your equipment the night before. (See the earlier sidebar "Getting the Gear Ready.")

2. Decide on a time to shoot. If you are going to do a twilight shoot, look online to find out when the sunrise or sunset is, and schedule your shoot according to that time.

3. If possible, find the spot you are going to photograph before arriving to the area you will be shooting. This requires that you go an hour or two earlier than your shooting time to find the right spot for shooting. Figure 17.4 shows a camera set up for photographing a California surf contest.

4. Attach your camera to the tripod.

5. Set up your camera and tripod while looking in the viewfinder and level to get a shot inline with the horizon, unless you are doing angled shots, which are up to your own discretion.

Figure 17.4 Canon 1D Mark III with Canon 300 mm f/2.8L lens and Gitzo tripod. Courtesy of Mike Baird Photos at www.flickr.com/photos/mikebaird/.

6. Check the ISO speed. It should be less than 200 ISO.

7. If you are going to shoot in Aperture Priority mode, set Exposure Compensation to the most underexposed value and set the aperture according to the amount of blur/sharpness you want in background. For a landscape photo, it will be anywhere from f/10 to f/32,

depending on the amount of light you have. (For decent light, make the aperture narrower; for low light, make the aperture wider.) If you are going to shoot in Manual mode with varying shutter speed, see the directions in Chapter 19, "Manual Mode."

8. Wait for appropriate light before you start shooting.

NOTE

Watch the number of shots you are taking. When you're shooting for HDR, you can quickly pile up dozens of photos, zapping your battery and filling your memory card.

9. When you're ready to shoot, either click on the timer and take your first (next) shot or use a cable release to shoot the shot.

10. Look at the shot. Increase Exposure Compensation by 1 stop. If you're finished with the set, reframe, zoom in or out, or move to a different spot.

11. Repeat step 9 and 10 until you get to the highest EV your camera (overexposure) can be set to.

CHAPTER 18
Aperture and Shutter Priority Mode

W hen you shoot high dynamic range (HDR), you need to be able to distin-
guish between Aperture and Shutter Priority mode. The former (the blue
number in Figure 18.1) you'll use frequently to take your HDR shot sets.
The latter (the red number in the figure) you probably will never use for this type of pho-
tography; however, it's good to know about it, because when you start using Manual mode,
the same concepts from Shutter Priority mode apply.

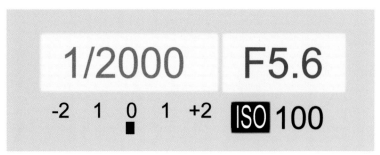

Figure 18.1 The number in red is the shutter speed; the number in blue is the aperture.

In the Chapter 11 sidebar "Aperture What?," I discussed what aperture was. Recall that the values shown on the camera are really the inverse of it. When you have set your camera to an Aperture Priority mode of 4, it means 1/4, which is usually written f/4. Also recall that when you're in Aperture Priority mode, you set the aperture (and the camera decides the shutter speed) when you turn the appropriate dial or change an aperture value in the menu on a point-and-shoot. The camera then makes the shutter speed changes after evaluating the light that is coming to the lens.

WHAT IS A STOP?

When the camera is set to Aperture Priority, Shutter Priority, or Manual mode, each small turn of the dial stops at a value. The values have been set so the difference in each either doubles or halves the light into the lens. A single turn until the dial stops is called a stop.

Changes in aperture, shutter speed, and exposure compensation are measured in stops. The shutter speeds and aperture values are the same numbers on all digital Single Lens Reflex (dSLR) and mirrorless cameras. For example, in terms of the aperture setting on any dSLR or mirrorless camera, changing the aperture from f/5.6 to f/4 one stop would double the exposure. To halve the exposure, you would turn the dial the other way, from f/4 to f/5.6. In terms of shutter speed settings, one stop would decrease the shutter speed from 1/1000 second to 1/500 seconds increasing the amount of light two times from one setting to the other. Decreasing the shutter speed by half would occur by going from 1/500 second to 1/1000 second (turning the dial the other way).

When your camera already has a set aperture and shutter speed, you can accomplish the same exposure changes using exposure compensation. The only trick here is that when you turn the dial once, you are only increasing the setting by 1/3 stop. To change it a full stop, you have to move it one EV unit, say, from −2/3 to −1 2/3. Most of the time you can set EV to −2, 0, +2 for three shots and −2, −1, 0, +1, +2 for five shots.

In Aperture Priority mode, you control the aperture. When you take a bracketed shot, you don't change the aperture or the shutter speed. It has to be constant so you get the same depth of field. What you do change, however, is the EV. When you change that, the camera doesn't change the aperture value; it only changes the shutter speed. For example, if you're taking an HDR shot, you probably want a narrow aperture for a landscape so that the foreground and background are sharp, so you might set it to f/10; then the camera will set your shutter speed according to how you've set your aperture and EV. In this case, you have no control of the shutter speed. The camera then calculates the shutter speed for each bracketed shot according to how you've set your EV.

In Shutter Priority mode, you turn the dial clockwise, and the shutter speeds are set so they are faster. When you change the shutter speeds, the camera controls the aperture so that each time you change a shutter speed, the aperture is likely to change, too. Most of the time when you are changing the shutter speed, the aperture changes. That means in an HDR bracketed shot, the image would not have a consistent depth of field from shot to shot, causing a merged photo from the bracketed shots to be soft in strange areas of the frame. Now, when you change the EV in Shutter Priority mode, the aperture changes, again not making for a very good bracketed set because of the different depth of fields you get with each shot.

As soon as you see the open quotation mark symbol (") in front of the shutter speed value, it changes to how many tenths of a second the shutter will stay open. For example, ".3 means 3/10. (The meaning of other values is given in the sidebar "Aperture What?" in Chapter 11, "Camera Phones.")

When you're shooting using Auto Exposure Bracketing (AEB), you don't have to worry about shooting with a fixed aperture. You might be thinking about why you can't change the aperture of a shot when shooting HDR while using a tripod. Recall that when you change apertures, you change depth of field; that is, you change what is sharp from front to back in the photo. When the aperture is wide, you get a lot of softening in the background. The narrower the aperture is, the sharper the entire frame is.

For a merged HDR shot, the wider your aperture, the less ghosting you'll get from moving objects and the more softness you'll see in the frame. It makes the best sense to shoot HDR handheld sets with wide apertures because your shutter speed will be faster and the shot sequence will be shorter.

Because you want to get as much detail as possible in an HDR, it makes sense to use a narrow aperture because that will give you sharpness in your foreground and background.

So, there are two ways you can take an HDR photo set. The first is in Aperture Priority mode, changing the exposure compensation each time you shoot (or use AEB). The second way is to set your camera to Shutter Priority mode, changing the shutter speed each time you shoot. Your camera settings will depend upon the lighting and weather conditions, which are discussed in Part V, "Field Conditions."

Manual Mode

M anual mode is when you control both the f-stop and the shutter speed. At first, controlling both of them might sound difficult. However, it is easy if you think about one setting at a time.

> **N O T E**
>
> You can use AEB (see Chapter 21, "Auto Exposure Bracketing") in Manual mode; however, it doesn't come up on LCD screen unless it's in the range where your light meter detects ample light for the values on your Light (EV) meter.

To understand why you would use Manual mode over Aperture Priority mode, consider how the camera functions in Aperture Priority mode. If you are shooting in Aperture Priority mode without using AEB, the camera will not take shots beyond the EV numbers shown on the LCD screen. For example, if you take your last shot at –2 EV at a shutter speed of 1/250 second and you want a shot at 1/500 second (or speed faster than 1/250) to capture more of an overlit area, the camera won't take the picture. Conversely, if your last shot was +2 at a shutter speed of 1/15 second and you want another at 1/4 second (or slower than 1/15) to capture more of the darker areas, your camera won't shoot.

Consider Figure 19.1. That shot isn't possible in Aperture Priority mode because when you're shooting at f/8, the shutter speed needs to go above its current speed of –2 EV (which was 1/250) so that it can be more underexposed. The shot in Figure 19.2 isn't possible in Aperture Priority mode either because the shutter speed needs to go below the speed it was at (+2 EV, which was 1/15 second).

Figure 19.1 Underexposed scene not picked up by AEB.

Figure 19.2 Overexposed scene not picked up by AEB.

The advantage of shooting in Manual mode is that when your camera senses an over- or under-exposure beyond the EV values, it displays on its LCD and still takes the shot. That enables you to capture details in highly dark areas in the frame without blown highlights in that part of the frame. (It blows everything except for very dark areas, which are made light enough to see details.) In addition, it captures other details in very light areas without heavy shadows.

For most digital Single Lens Reflex (dSLR) cameras, there will be two dials to use in Manual mode that you can use to change aperture and shutter speed values. One is for aperture, and the other is for shutter speed. When shooting a high dynamic range (HDR) shot sequence, you first need to set your aperture to the value you will use during the entire set.

An example of using Manual mode for HDR photography would be shooting a group of images like those shown in Chapter 25, "Night Landscapes." After looking at those images, you get a good idea from the captions that the shutter speed varies while the aperture remains constant.

Shooting an HDR set using various shutter speeds is most common during twilight when the sky becomes a deep, dark blue. There are several ways to go about setting your camera for the shot sequence. You have to keep in mind that you have a time constraint. If you want the twilight sky, you have to work quickly. Remember that you will be shooting with long shutter speeds, so shooting a few HDR sets from the same place will take at least 15 minutes—a time period when the sky changes quickly. You'll probably want to get HDR sets from a few different places. The sky is a good color for only a short time, so plan on going to just two or three places to shoot.

> **NOTE**
> It's best to set your camera to evaluative or center-weighted metering before you shoot.

The first thing you must consider when using Manual mode is that you use the Exposure Compensation Indicator as a light meter. You can focus and meter in manually or use autofocus. The drawback to autofocus is that you need a light source and contrast for it to work. If you try to autofocus on a dark sky, your camera can't do it. If you're not pointing at a light source, you have to move your camera, set the focus, and move it back while your finger is pressed halfway down on the shutter release or the cable release, which can be challenging. You can, however, autofocus on the dark sky in Manual mode.

> **NOTE**
> Your EV meter will start blinking when your camera believes it can't underexpose correctly. You can ignore this when you're shooting at night.

After you press your shutter halfway down, your camera displays the shutter speed, and you see the EV meter at 0. Now change your shutter speed while looking at your EV meter, and lower it with the dial until it reaches the most underexposed (biggest minus value) point on the EV meter (–3 or –4). If your EV meter only goes to –3, lower your shutter speed a few stops more.

Now you're ready to start shooting, keeping in mind that the next part, increasing the exposure, isn't an exact science. Don't try to do it using the EV meter because it jiggles too much—something you don't want to deal with, especially when it's getting dark outside. Also, don't worry about how many shots you take. You can worry about that later.

After estimating a shutter speed where the brightest highlight has detail (relatively fast, on order of 1/2000 second), shoot your picture. If you've got blown-out whites with no detail left in this shot, decrease your shutter speed until you get detail in the image's brightest area. Then increase your exposure a few stops. Shoot again. Keep taking pictures and looking at your LCD screen until your image has several areas of blasting highlights. Stop shooting. Figures 19.3 through 19.7 show the sequence of shots and the shutter speeds of an example. Figure 19.8 shows the five images merged using Photomatix (see Chapter 33, "Photomatix—A Quick Run-Through").

Figure 19.3 4 seconds at f/11.

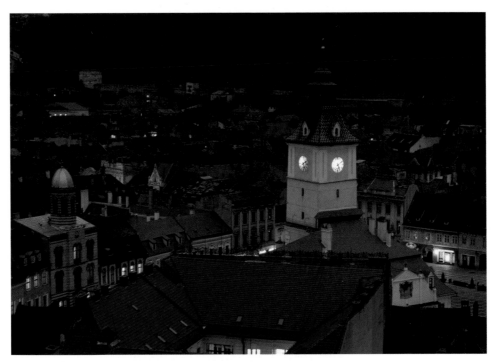

Figure 19.4 8 seconds at f/11.

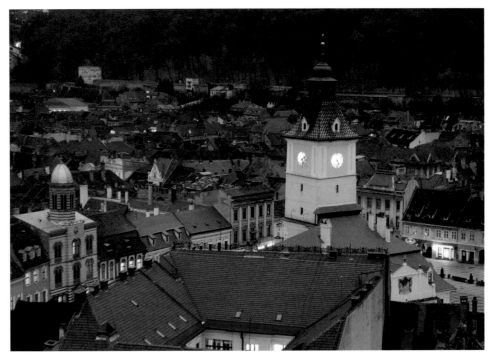

Figure 19.5 15 seconds.

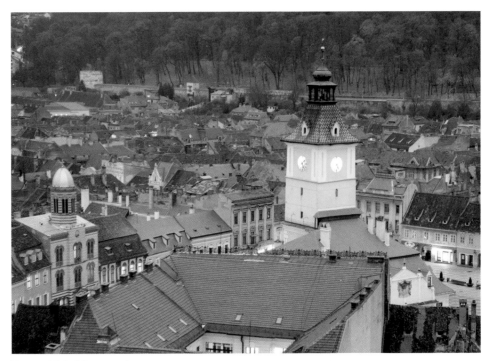

Figure 19.6 25 seconds.

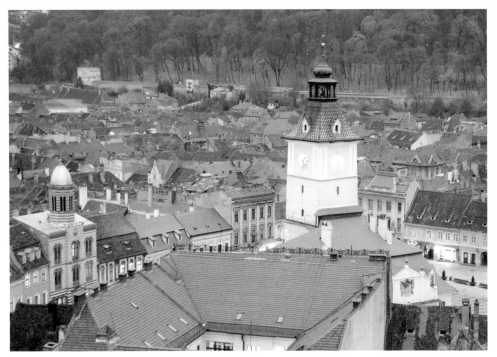

Figure 19.7 30 seconds.

Figure 19.8 Five shots merged in Photomatix.

CHAPTER 20
ISO Speeds

So far you've learned about exposure compensation, Auto Exposure Bracketing (AEB), f-stop, and shutter speed as they apply to high dynamic range (HDR) photography. In this chapter, I'll give a few tips for setting ISO speed and some additional tips for exposure compensation and bracketing.

First, take a moment to consider exposure. Exposure is not only controlled by shutter speed and aperture; it is also controlled by ISO speed. ISO speed is a measure of the sensitivity of your sensor to light. It can be very sensitive to light when it is set to high ISO speeds and not very sensitive to light when it is set to low ISO speeds.

Have you ever started taking shots with your camera without looking at your ISO speed? Perhaps you started shooting and all your images were overexposed. You might not have changed your ISO from the night before so that daytime shots mostly showed blown highlights. When the sensor is highly sensitive to light, the shutter opens and closes faster (shorter shutter speed). At high ISOs, your photo is very susceptible to noise (see Figure 20.1), because when your sensor is exposed to light quickly as is the case at high ISO speeds, some pixels tend to be lost and noise is created. On many cameras, anything greater than ISO 800 is considered high.

Figure 20.1 High ISO speeds can make your photo noisy.

Low ISO speeds result in crystal-clear images without a speckle of noise. At low ISO speeds, your camera's shutter opens and closes more slowly so that it can take in the light, slowly picking up all the necessary pixels to make a noiseless image (see Figure 20.2).

Figure 20.2 Low ISO speeds are not likely to have noise.

Blur is also a factor when taking a picture at low ISO speeds (see Figure 20.3). Because the shutter is open longer, there is more chance for camera shake. If you've ever seen a photographer carrying around a tripod on a sunny day, he is more than likely using low ISO speeds and shooting some photographs in the shade.

Setting your camera's ISO speed is vital to get a good shot. Table 20.1 shows some good ISO speeds' various circumstances.

TABLE 20.1 Choosing the Best ISO Speed

ISO Speed	Weather/Time	Light/Gear
100–200	Sunny	Outside
100–200	Anytime	With tripod
400	Sunny	In shade
400	Day	Candid and HDR
400	Overcast	Outside
800	Sunny dawn/dusk	Shade or outside
800	Night under light	Inside or outside
1,600 or above	Night little light	Inside or outside

Figure 20.3 Blur is more likely to occur in images taken at low ISO speeds.

N O T E

If you're walking around with your camera, shooting candidly, set your ISO speed at 400 to make sure you freeze the scene.

One of the most important things to remember regarding ISO speeds, like the f-stop, is not to change them in an HDR photo series. Changing them could result in your final HDR image to take a set of pictures where each shot really isn't different from one of the others in terms of exposure. For example, if you take one shot at −2 EV and 100 ISO, another one at 0 EV and 800 ISO, and a last one at +2 EV and the same ISO speed, you'll come out with one shot that's properly underexposed and two shots filled with blown highlights from overexposure. That's because a shot taken at 0 EV and 800 ISO will be overexposed, and a shot at +1 and 800 ISO will be grossly overexposed. Recall that when the ISO is higher, there will be more light that reaches the sensor, because it is highly sensitive.

Auto Exposure Bracketing

You might be led to believe that Auto Exposure Bracketing (AEB) is a difficult concept—both in understanding what it is and setting it on your camera. The concept of it is simple. Routinely, it involves taking three exposures: one that's underexposed, one that's normally exposed, and one that's overexposed. Your camera needs to be capable of taking AEB shots with a maximum range of 4 (for example, +2 EV to –2 EV) and with at least three continuous shots. Figure 21.1 shows two configurations of AEB that are used on many digital Single Lens Reflex (dSLR) cameras. It is somewhat limited because it can only take three AEB shots with a maximum range of 4. The top of the image shows the camera set to take three rapid progression images (finger holding down the shutter release until the camera stops taking the three shots). The EV increment of each image is 2 stops. When you reset the AEB, the two outside markers spread out from one another. When the camera is set to take pictures in increments of 1 stop, the two outside markers move inward 1 stop, as shown in the bottom of the figure. Most dSLR cameras can do this and more.

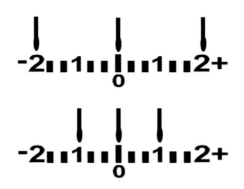

Figure 21.1 Camera AEB set in two different ways.

AEB permits the camera to automatically take a number of rapid-fire shots in a small incremental time frame. When you shop for a camera, you probably want to look at the maximum number of frames per second at which the camera shoots. The value is given in frames/second. The more frames per second, the faster the shots are, and the less time between shots of different exposure, so you are more than likely to keep the camera steady from shot to shot to increase your chances that there is little difference from shot to shot. If there isn't too much difference, high dynamic range (HDR) programs do a pretty good job at aligning your images. If you are interested in taking the best HDR shots, look for a camera with a high frames/second rate. They usually run from three to five frames/second, but on some later models they run up to 10 frames/second.

Not all HDR photography is dependent on how fast your camera shoots in frames per second. To be sure, it's nice to have a camera that you can depend on to focus quickly and take shots one after the other, but you can still take an HDR if your camera isn't the fastest one on earth. Fast shooting speed comes in handy when you're using AEB. On most dSLR camera models, AEB requires that you keep your shutter pressed down as you shoot. To be sure, you probably will elect to do this with handheld HDR shots, but you won't if you are using a tripod or have set your camera on a sturdy surface. You'll use the timer or cable release instead. The faster the shooting, the better your HDR shots will be because camera shake will be of a shorter duration.

The nice thing about HDR photography using AEB is that you only focus once, whereas when you're using a tripod, you're most likely taking three separate shots, each time the camera refocusing on the object. This brings up two issues: camera shake from the mirrors moving and the pressure on the shutter button. Both can be minimized by using a shutter release cable.

The best HDR shots come when you use a tripod and 4–6 more exposures than your AEB setting can handle. (Many offer the option of only three shots.) If that's not possible, you can get a good HDR shot set using AEB when shooting handheld on the street. Those shots come out well on sunny days when taken with abundant ambient light.

Finally, the best way to use AEB is with a shutter release cable and a tripod. This cord enables you to shoot without pressing down the shutter release on the camera, thus reducing the possibility of camera shake from your finger, putting pressure on the camera's body. The tripod will ensure that your camera is steady when you are taking the series of shots.

The best AEB can be achieved with the expensive Canon 1D Mark IV cameras, which are capable of bracketed exposures from 1/3 to 3 stops, making these models bracket over a range of 18 stops. The worst are Sony's Alpha camera models and some mirrorless models because they have a limited AEB range. With 2 stops as the maximum AEB range (−1, 0, +1), point-and-shoot models also have a limited range with AEB. Many of the Sony Alpha dSLR models have a maximum EV increment of 1.4 with their EV step increment of only .7. This isn't enough to pick up all the details from both the shadowed and highlighted areas at the same time. One of the exceptions to this limited AEB range is the Sony A900 when it is updated with firmware. That camera is capable of a maximum step increment of 3, with a range of 6 (from −3 to +3).

NOTE

You can use AEB with a timer; however, because you have to hold down the shutter release button for a period of time, it doesn't work out well when you are shooting longer exposures.

ADJUSTING THE AEB ON A DSLR CAMERA

Adjusting AEB on a camera is a simple process of setting it in the menu of most cameras. Figure 21.1 shows what the option looks like up close. Again, the top of the figure shows AEB set up for three shots: one at +2, one at 0, and one at −2 EV. The bottom also shows three shots, but at +1, 0, −1 EV. To get there, you roll the dial on the back of the camera to the AEB setting. Then you press the button in the middle to set. Once the AEB blinks, you can turn the big dial again to make the cursor on the AEB scale move outward from the middle. If the camera takes three continuous shots, there will be three markers: one on the negative end (underexposure), one on the positive end (overexposure), and one in the middle. As you turn the big dial, the exposures increase and decrease simultaneously. After you've set the dial where you want (most of the time −2, 0, +2), you press the button in the middle to make the setting activate on your camera. The small LCD screen at the top of the camera should be blinking.

To take the HDR shot, you have to press the shutter release and keep it pressed until it's finished shooting. If you don't, the 3-shot set won't be complete, so that the next time you shoot, you'll probably get the last one of the set (if only two shots were made).

You can skew the exposure compensation values of the shot by moving the 0 marker into the over- or underexposure area of the scale. This causes the camera to set different under- and overexposure values. If you move it 1 stop to the left, the camera shoots at −2, −1, +1. If the camera could shoot at +3 to −3 EV, it would set at −3, −1, +1 because there are now two stops to the left of the −1.

When you look for a camera, keep in mind that the larger the range of the EV, the more you'll be able to under- and overexpose. Some cameras take five or seven shots at different EV increments. It's something to consider if you're planning to shoot HDR sets.

PART V

Field
Conditions

CHAPTER 22
HDR on a Sunny Day

Weather conditions play an important role in high dynamic range (HDR) photography. Before you set out to take HDR picture sets, you need to consider what type of lighting you are going to have, which, for the most part, is dependent on the time of day and the location of your shot. Your goals for shooting HDR will change according to the weather or the amount of sun surrounding your subject. For example, the dreaded detriments of a cloudy day are just about eliminated because HDR picks up clouds better than you can see them with your naked eyes. I'll start out with what to look for and how to shoot on a sunny day.

When it's sunny, HDR photos, like any photo taken with the sun in front of you, create heavy shadows in the foreground, as shown in Figure 22.1. The goal of your photograph under these conditions is to ensure that the shady areas are visible in your long exposure shot. That happens when you take the overexposed shot, leading to an HDR photograph that really brings out the details in the foreground. The image in Figure 22.2 enhances the foreground detail after it's merged into HDR. The photo was taken at dusk with the sun facing the photographer, so a large whiteout area appears in the sky.

Figure 22.1 Darkened foreground when shooting into the sun.

Figure 22.2 More detail and color come up after merging into HDR, even when you've shot into the sun.

TIP
Shoot into the sun; you're likely to get blown white highlights at dusk and dawn.

Sometimes when you take a photo with the sun behind you, there is such a brightness differential in the scene that your camera doesn't expose enough of the shadowed areas when taking your overexposed shot. That causes you to lose detail in the shadow areas of your shot, which is not a good characteristic for an HDR photo to have. Figure 22.3 shows a merged shot that had been combined with an HDR set that contained an overexposure without enough detail in the shadowed areas. That shadowed area in the overexposure hid the purple detail in that part of the scene, which meant that the HDR merge had a darkened black shadow blocking the detail of the scene. The overexposed shot needed more light in the scene to bring out the purple detail. Had the shutter remained open for a little longer in this overexposure, there would have been enough light hitting the sensor to make the purple detail evident in the shot of the scene and in the HDR merged shot. You could lighten it using tone mapping or Photoshop, but when that

area is brought out, there is a lot of noise. The remedy for this is to shoot the HDR set again with a higher exposure, look at the overexposed shot in your LCD screen, zoom into it, and make sure the last shot contains all the details you need in the shadows. If the initial overexposed shot was at 2, which is the most overexposed you'll get using some cameras, the only option you have is to reshoot the image with a larger aperture (say, from f/11 to f/5) without changing the exposure compensation. Most newer digital Single Lens Reflex (dSLR) camera models have AEB settings that extend to +/−3 to 4 stops, so it's possible to increase the AEB increment to overexpose enough to create details in the most heavily shadowed areas. Some older models (such as the 5D, which only extends to +/−2 stops) don't extend enough, so you have to shoot without AEB.

Figure 22.3 Failure to overexpose enough in your HDR set with the sun behind you causes dark shadows to remain in the image.

Cloudy Day Details

W hen skies are cloudy, you can obtain superior results when you underexpose enough to bring out the shape and color of the cloud pattern. The final high dynamic range (HDR) shot on a cloudy day can be phenomenal (see Figure 23.1) if you merge the photos and adjust the tone mapping to Surreal in Photomatix. (Steps for doing this are in Chapter 33, "Photomatix—A Quick Run-Through.")

Figure 23.1 Surreal effect enhances cloud cover.

CLOUD TYPES AND HDR PHOTOGRAPHY

Two types of clouds can affect your HDR shot: stratus clouds and cumulus clouds. On cloudy days, you may see one or the other or both. Exposing the clouds correctly, or getting the most detail in them, requires that you look at each of your shots after it's taken to see how you've done with the settings you've chosen. Expect the overexposed shot to blow the highlights of the clouds. The normal and underexposed shot should contain no blown highlights. Your camera's LCD screen will show the blown highlights by displaying blinking red in the areas where the problem exists.

If stratus cloud layers—often gray and unappealing—fill the sky, you want to get the best exposure that you can of the sky; HDR photography gives fine details to the clouds so that the grays are divided into different shades of gray and blue, making them much more compelling. You might have to play with the image in Manual mode (keeping the aperture constant) to get a shot underexposed enough to bring out the details in the clouds so you can adjust shutter speed while keeping the same aperture. On these days, you need to look at the underexposed shot to ensure you get the maximum details of the cloud layer and adjust your camera accordingly. Figure 23.2 shows an HDR image that was processed from three images taken on a day when a bank of stratus clouds covered the sky.

Figure 23.2 Stratus clouds are layered.

Occasionally the sky is filled with cumulus clouds growing upward, which later turn into cumulonimbus clouds that cause thunderstorms (Figure 23.3). The skies then are usually a great shade of blue when your back is toward the sun, allowing you to capture some brilliant luminescent colors and enhanced contrast between the white clouds and the blue sky for your HDR images.

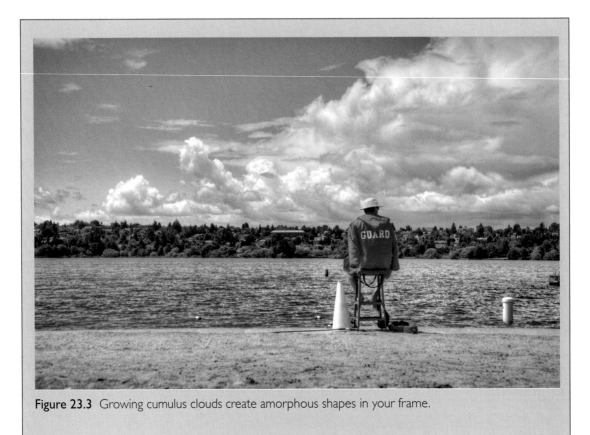

Figure 23.3 Growing cumulus clouds create amorphous shapes in your frame.

At the beginning and end of cloudy days, you have to be extra careful with your underexposed shot because it could turn out black from improper light hitting the sensor. You can increase the exposure when you shoot by increasing your apertures or decreasing your shutter speed.

NOTE

When you open up your aperture, more of your shot will be out of focus, which causes the depth of field, or area of sharpness in a photo, to decrease.

On dark cloudy days when rain has fallen, you need to increase the exposure of the HDR set you are shooting to get more detail in it. You can do this easily by increasing the exposure compensation for the exposure bracketing. All three of the markers on the Exposure scale move to the right (unless the overexposure marker is at the highest value), increasing the exposure of your underexposed shot.

You can base your decision about whether to create an HDR-like photograph using a single image by assessing the type of cloud cover in the image. (See Chapter 32, "Simulating HDR Using a Single Photo.") To be effective, this process requires creating under- and overexposed copies of the original using Adobe Camera Raw (ACR) so that you have three images in which to create process using HDR software. The processed underexposure requires the original to be light enough so that when you underexpose by 2 stops, large sections of your frame don't turn black. The processed overexposure requires the original to be dark enough to limit the production of blown highlights if the exposure is increased by 2 stops.

A partly cloudy day with many cumulus clouds is likely to contain enough light to effectively process under- and overexposed photos to create a decent tone-mapped image. In those conditions, the sensor receives more information than it does on cloudy days; therefore, when you change the exposure, it's much less likely to lose detail, contain noise, and have many clipped shadows and blown highlights.

Day Landscapes

D ay high dynamic range (HDR) landscapes can be some of the best HDR images you'll make. With sky and land contrasting each other, the possibilities for enhancement through the merging of photographs are seemingly limitless.

Much has been written about these landscapes being overprocessed, too surreal, or too cartoon-like. Whatever your thoughts are about that, the fact is some people like that. If you don't like it, there are options you can use in Photomatix to make your photo more realistic.

You have to realize, too, that HDR software may not get you completely what you want. You might like the image the software has produced but find it has noise and softness. If there's not too much of that, you can repair it in Adobe Camera Raw (ACR). (See Chapter 4, "Adobe Camera Raw Photograph Attributes.")

In Figure 24.1, I began with an image that was taken on a hazy day. Start with an image like that, and the final product will be riddled with noise when you've finished merging the photo set. However, that noise is only apparent when you view the photo at 100 percent resolution. You can eliminate it through some skillfully made adjustments using the Sharpening and Noise Reduction tools in ACR, which are described in the sidebar "Cleaning Up Your Image in ACR" in Chapter 32, "Simulating HDR Using a Single Photo."

Figure 24.1 Improve the appearance of daytime photos by taking several exposures and merging them.

In short, HDR landscapes do for your photo what multipurpose cleaner does to clean the counters, sinks, and windows in your home—you can use HDR for day landscapes to enhance a photo in just about any weather conditions. You can reduce haze, as shown in Figure 24.2. In addition, you can improve shots where the sun is behind you by eliminating some of the darker shadows in nooks and crannies of the frame and replacing it with details that can improve a photo significantly.

Figure 24.2 Luminescent blue covers the sky before dawn and after dusk.

THAT PERFECT TIME OF DAY

There's a time of day, whether it's sunny or cloudy, that the sky turns navy blue. Just before dusk and just after dawn, the color is jolting, however briefly. You can create a first-class image with or without HDR during these times.

Here's how it usually goes. Just as the golden sun sinks below the horizon, the sky in that direction will be almost white from the Western light. In the opposite direction, it will be light blue or golden, depending on the cloud cover and how much haze/smog you have. In another 15 minutes, or about 30 minutes before total darkness when the city lights are turned on, the sky deepens in color so much when it's photographed that it hardly looks real. What's incredible about this is that it happens even when the sky is decked with clouds. It's a time of day you don't want to miss with your tripod and camera.

Two drawbacks of this 20-minute window of color are that you need long exposures and at least a few lights in the foreground (cars, street lights) for a good shot, making any handheld shot ineffective with major blur.

It's a big help if you know where you want to photograph during this time so you can set up your equipment first. Also, don't expect a dozen or more shots, because the exposure times are long, and it takes a good bit of time to frame the shot with so little light. The way you set your camera changes too, which is discussed in Chapter 25, "Night Landscapes."

Night Landscapes

Night photography is a whole different ball game when you are out in the field shooting multiple sets of photos for high dynamic range (HDR) processing. To get good images at night, you have to work with long shutter speeds and pay close attention to camera setup. It takes a long time to get a few sets—close to half an hour.

Because this book is made for beginners, I'll show you the easiest way to get great HDR night photos. There are two things to keep in mind: your aperture has to remain the same, and it's best to use Manual mode because it's easier to find the point at which your shot is the most exposed. In Manual mode, you can change apertures easily with a dial until you get an exposure that reaches the most overexposed stop on the exposure compensation scale.

At night, there comes a point when the amount of light won't let you fully overexpose your shot because your camera needs more than 30 seconds' exposure time to do it. When this happens, the 30-second shutter speed blinks on and off, and the exposure compensation blinks at its highest stop (which is +2 or +3 depending on the camera make and model) when you press the shutter release halfway down. The red mark below the +2 in Figure 25.1, which indicates a blinking cursor, roughly shows how the settings look on the LCD screen at the top of many digital Single Lens Reflex (dSLR) cameras, when there's not enough light to take the longest exposure possible in the Manual mode. The camera won't take a shot if you are using the auto focus.

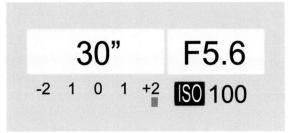

Figure 25.1 When there is little light, the most over-exposed shot will take longer than 30 seconds.

When shooting in Aperture Priority mode, the blinking cursor will happen first if you are shooting with narrow apertures (for example, f/22). To be sure, you can widen your aperture (for example, to f/4). The shutter speed will stop blinking, and you'll get different exposures, but the depth of field will change so that your picture will be soft in some places. This will work sometimes, but it is better to retake all the shots in the set at a wider aperture (for example, f/6.3 instead of f/22).

When you shoot at night, with Auto Exposure Bracketing (AEB), you'll end up holding down the shutter seemingly forever, which causes your camera to shake. For this reason, a cable release is necessary. For shots with lengthy shutter speeds, you could use Bulb mode to get exposures longer than 30 seconds. Bulb mode requires you to hold down the shutter release for the exposure time, but I'm saving more details about that process for an intermediate book.

Another factor is autofocus. The camera needs bright enough light and contrast to autofocus. (An additional option for shots in the dark is use of manual focus.) If you want to use autofocus, you have to press your shutter halfway down to a source of light. If you're shooting a nightscape, your camera will probably be pointing at the dark sky, where the autofocus won't register. That will cause your camera red autofocus light to flutter; when you press all the way down, your camera will do nothing, which is frustrating to say the least.

At the end of the day, once you get past a certain hour (or before a certain hour if you're talking about sunrise), taking an HDR photo doesn't work well using AEB, or for that matter with the exposure compensation setting, the usual way of taking an HDR set.

NOTE
HDR pictures of the moon are not advised because the moon moves too quickly during the long exposures, causing considerable motion blur.

Now that you understand the limitations of AEB and exposure compensation, it's a good time to look at an example of a photo set taken in Manual mode that resulted in a great HDR image.

You don't have to know how many shots you'll have to take for a nighttime HDR photo as long as it's at least three, each with a different exposure. For the bridge photos shown in Figures 25.2 through 25.6, I started out making a long exposure for my most overexposed shot; then I made the shutter speed of each shot thereafter a couple of seconds shorter than the one before it. I stopped shooting when the shutter speed was 2 seconds, the resulting image shown in Figure 25.6.

I looked at the beginning shot after the shutter release closed to see if I had adequate overexposure. Then I continued shooting, increasing the shutter speed for each shot. When each change was made, the exposure compensation bar appeared, each shot's cursor moving down a few stops toward the most underexposed value. The exposure compensation bar guided me, showing me the extent of overexposure as I decreased the shutter speed.

Figure 25.7 shows the resulting HDR image after merging the five photos shown in Figure 25.2 through 25.6.

Figure 25.2 f/22, 25 sec.

Figure 25.3 f/22, 15 sec.

Figure 25.4 f/22, 8 sec.

Figure 25.5 f/22, 5 sec.

Figure 25.6 f/22, 2 sec.

Figure 25.7 HDR shot made by merging five shots of different exposures.

CHAPTER 26
Inside/Outside Shots

Shooting outside on a sunny or partly cloudy day is easy because you can set your Auto Exposure Bracketing (AEB) and then shoot without a tripod. Shooting this way enables you to get some good candid photography that you can process to make a high dynamic range (HDR) photograph.

HDR photos shot with indoor and outdoor parts in the frame are especially effective in bringing out details that wouldn't be there with a normal exposure. Figures 26.1 and 26.2 show the blown highlights in the outside part of the shot. Whenever you're shooting into light as you would from the inside of a building that looks outside, you get blown highlights from the outside areas.

Figure 26.1 Blown highlights in overexposed image.

When you use an HDR set, you can merge the three exposures, one of which will be underexposed (Figure 26.3) so that all parts are heavily shadowed except for the outside, which is usually well exposed. Figure 26.4 shows where the HDR image will pick up the details in the outside areas. In this shot, I tweaked using Photomatix Pro, Adobe Camera Raw (ACR), and Photoshop CS5 and CS6. The merged HDR set can reveal the details of an indoor shot if it shows part of the outside—such as what's behind open windows, doors, and hallways—without compromising the indoor portion of the shot.

Figure 26.2 Blown highlights in normally exposed image.

Figure 26.3 The underexposure picks up the details in the outside areas of the photo.

Figure 26.4 The HDR shot picks up the outside details without affecting the exposure inside.

To shoot indoors when there is little or no sunlight in the frame, you need a tripod. No matter how good the artificial light in the room, there's usually not enough to take a sharp handheld series of shots. Figures 26.5, 26.6, and 26.7 show three exposures taken indoors with little light using a tripod in Dracula's Castle (Romania). Figure 26.8 shows the result.

You might look at the underexposure and think that not enough information is present for the HDR merged shot, but there is. That shot gives you the details where the highlights were blown in the normal and overexposed shots at the top left of the frame.

CAUTION
Never attempt a shot like the one in Figure 26.4 with people. The show shutter speed resulting from the low light is sure to make your photo blurry.

Figure 26.5 Overexposure brings out detail in the shadows in the merged HDR photo.

Figure 26.6 Normal exposure doesn't give you details in the shadows or highlights.

Figure 26.7 Underexposure gives you details in the highlights in the merged HDR photo.

Figure 26.8 Final merged HDR image.

PART VI

Accounting for Special Situations

Close-Up and Still Life Images

Although close-up and still life images don't appear as dramatic as landscapes when shooting and merging to make HDR, you can get some rather good art photographs.

The deghosting tool in Photomatix is the best around. Close-up portrait images are unique in that there's no way for your image to be ghost-free when you shoot handheld, and there's just a slim a chance when you shoot with a tripod because of the movement of the subject. This is especially true when you're shooting candidly on the street.

> **NOTE**
>
> Ghosting is a kind of movement blur that HDR programs can remove.

Hand-holding your camera causes it to tilt up and down and swing left and right from the rocking of your body or the shaking of your hands. Close-ups of people blur (ghost) over multiple shots when you hand-hold your camera and use Auto Exposure Bracketing (AEB), regardless of how much you move or how much your subject moves. The movements are so small that you can't really see them, but your camera does.

Still life images are only affected by camera shake; the objects never move. In contrast, live subjects are subject both to their own movements and the movements of your camera as you hold it.

> **NOTE**
>
> The amount of movement of the image on the sensor depends on the focal length of the lens; the greater it is, the more chance there is for movement blur.

The program Photomatix can easily fix camera shake by making selections around the ghosted parts of the image. When there's a lot of ghosting, Photomatix doesn't do a perfect job, but if you spend some time with it by previewing different sets of selections, it's pretty effective.

Take, for example, the set of three images that have been merged in Figure 27.1. The photo has some slight softening and some ghosting along the right side of the face. You can make a high dynamic range (HDR) photo from it, but it is a bit less flattering than the original image shot at normal exposure shown in Figure 27.2. To be sure, you can get rid of the oversharpness of the image (not recommended for portraits of younger people) by reducing the Clarity setting in Adobe Camera Raw (ACR), but then you end up with something close to your original image.

Figure 27.1 Tone mapping doesn't do much for portraits of younger people.

Figure 27.2 Good exposure for portraits of young people is all you need, so HDR isn't worth it for them.

HDR photos of very old people can be very compelling because, in some cases, you want to enhance the fine lines in the face. However, if you get a good exposure of a very old person, you can tone-map one image (see Chapter 32, "Simulating HDR Using a Single Photo") instead of a series of shots because you'll be assured there is no movement in the subject.

In the Align Source images option in Photomatix, you get two choices to align your images: correcting horizontal and vertical shifts, or matching features. The former aligns the image in only two ways: moving it from side to side or moving it up and down. The latter aligns the image using both the horizontal and the vertical shifts and the rotation and translation.

When processing the image into an HDR photograph and then tone-mapping it, the first thing I did was to deghost the young woman's face using selective deghosting. (You'll learn more about that in Chapter 33, "Photomatix—A Quick Run-Through.") Selective deghosting does a great job of aligning the images correctly and reducing softness.

Figure 27.3 shows the image after it was deghosted and merged. You can see that much of the softness has been sharpened both with the Deghosting tool and the software's alignment of the images while the photos were being merged.

NOTE

When the ghosting is severe or when you have to make a lot of selections to remove the ghosting, the picture can distort/stretch. However, the distortion is usually not too noticeable unless you compare it to the initial shots.

It might seem as if the definition of still life should apply only to paintings. I mean, why go to all the trouble of setting up a scene with inanimate objects and sophisticated lighting just to take a couple of photographs of it? In my book *101 Quick and Easy Secrets to Create Winning Photographs*, I talk a lot about still life images and how easy they are to create without doing any setup. All you do is take a walk and observe the items people have arranged around you.

NOTE

A still life photograph consists of inanimate objects set up in multiple dimensions (width, height, and depth) with interesting light, often with a subtle symbolism of the setup.

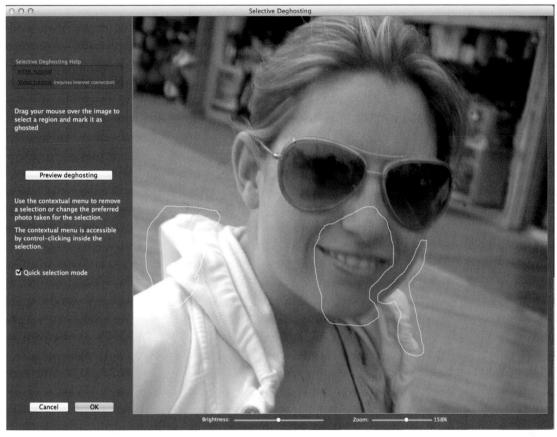

Figure 27.3 Selections to remove ghosting in Photomatix.

As I mentioned before, still life images are different in HDR from portraits. HDR and tone-mapping of still life images can make your picture pop out of the page.

A still life image takes well to the HDR process, whether you want a more realistic tweak (Figure 27.4) or a grossly overdone one (Figure 27.5). Because you're working with a variety of dimensions, the capturing of each shot at a different exposure captures many more details than a single exposure would. You have a choice as to how much shadow you want to create when processing. When you work with the photo, you are able to add or take away details from areas where there would otherwise be blown highlights in a normally exposed photo that hasn't been merged.

Figure 27.4 HDR that looks more realistic.

HDR works better for still life images than it does for close-ups of people for two reasons:

1. Still-life subjects don't move, so even if the shot's handheld, you've significantly reduced the movement blur.

2. You can get away with going overboard for still lifes. If you try going overboard with a human subject, you end up with one very wrecked-up person—every blotch, discoloration, and line that marks the person's face shows up, and then some. As I mentioned before, for some shots of the very old, HDR works well.

Figure 27.5 HDR that some people would say is overdone.

Flash Photography

Most novice photographers don't pay attention to the pop-up flash on their point-and-shoot cameras. They let it go off according to the brightness of the light in the area where they're taking a picture by keeping it in Auto mode. More seasoned photographers know that flash photography is more sophisticated, requiring the use of a dedicated (external unit that electronically matches specific camera models according to specs from the manufacturers) flash that permits them to set the amount of light the flash emits. It's used when there isn't enough available ambient light, when light needs to be balanced, when more light is needed in the background/foreground, and various other circumstances. During the day, flash can be used as fill light. For example, if a person is wearing a hat and you don't want his or her face to be shadowed from it, you can use a fill flash.

Flash is peculiar in that you need to change the aperture, not the shutter speed, to get different exposures; the flash, most often used as the main source of light, is instantaneous on the order of 1/1000 of a second. When it's relatively dark, a camera only sees the brightest light in the flash, which is of short duration, making exposure times and light available from the surrounding inconsequential to the amount of light the flash produces. Most consumer-grade pop-up flash units on a digital Single Lens Reflex (dSLR) or point-and-shoot camera only throw light so far. Areas where the light doesn't reach have too little light for details to show up.

You'll have a much easier time creating a high dynamic range (HDR)-like photo from images whose frames are covered entirely by either the light of the flash or the light of the flash and ambient light. The former happens in a close-up shot where the light from the flash covers the entire frame, as shown in Figure 28.1. The latter (Figure 28.2) shows that the flash only goes so far, and the background is heavily shadowed. When you create an HDR photo from that type of exposure, you get too much background noise because the software doesn't have enough details in the flash shot in that area, even when using Adobe Camera Raw (ACR). Most software programs can't eliminate it.

Figure 28.1 An HDR-like (tone-mapped) photo using a one-flash image with light from the flash filling the entire frame.

Figure 28.2 Flash goes only so far, leaving the background dark.

To remedy this, the shot requires a slow-sync flash, which is the kind of flash you get when shooting with an external flash unit in Aperture Priority mode on many cameras. Because you have to use long shutter speeds to pick up the ambient light in the background, you need a tripod to steady your camera.

Most dSLR and mirrorless cameras have a built-in flash unit. Some professional cameras require that you use an external flash unit because they don't have an in-camera flash. To accommodate a flash unit, these cameras contain what is called a hot shoe, a metal grooved piece on a camera to connect to the external unit.

If you're a flash beginner, it's best to use the Through the Lens (TTL) mode, whereby the flash unit makes all the decisions about how much light goes out based upon your camera settings. The flash unit usually measures the light with a pre-flash.

Part of the purpose of an external flash is to be able to swivel it in many directions so that you can control its path when you shoot. In many circumstances, you want to bounce the light by aiming the flash at a white wall or ceiling so you can bounce a softer light back on the subject.

N O T E

For beginning photographers, there is a 4-4-4 rule for setting your camera when it's using automatic flash (TTL). The rule entails setting the camera with an aperture of 4, a shutter speed of 1/40 second, and an ISO speed of 400. If you use this rule, you'll get good but not great lighting in low-light situations.

When dealing with flash photography, remember that your shutter speed is really controlling the ambient light that is let in, and your aperture is exposing for the flash. It's difficult to get three different exposures at the same aperture using flash because the light from the flash does not vary from shot to shot. The only part of the shot that will be HDR-like is the background, where the ambient light will increase when shutter speeds are lengthened for each shot in the HDR sequence. Creating an HDR photograph can be done, but not simply or in the way you might think. Real estate photographers sometimes take an HDR set without flash of a property they're trying to sell. The HDR will get some light in the shaded areas, but sometimes it's not filled with enough details. In this case, they use a special long-range flash to catch the details and then "paint" the photo with the detailed flash shot in Photoshop.

One simple way an HDR photographer can take an HDR-like shot using flash is to use ACR (see Chapter 4, "Adobe Camera Raw Photograph Attributes") to create underexposed and overexposed photos and then merge them using HDR software as was done in Figures 28.1 and 28.3. The result of the merging can be disappointing because there is significant noise created when you make the overexposure in ACR. A step-by-step guide of how to do this is in Chapter 32, "Simulating HDR Using a Single Photo."

Also, set your self-timer to ON so that the camera will wait a few seconds before it shoots.

Figure 28.3 You can make an HDR-like image with one flash exposure, but if there are any dark areas in the image, you'll get substantial noise.

PART VII

Postprocessing

File Types for HDR

A s a beginning high dynamic range (HDR) photographer, you only have to be familiar with three file types: Raw, TIFF, and JPEG.

JPEG Images

JPEG files have two primary advantages. The files are compressed, making it easy to control image quality because the files aren't so big. Also, keep in mind that the camera controls a lot of the tweaking of the image before the image is delivered to you as a JPEG, saving beginning photographers from having to do it themselves.

JPEG files are the most common file type on the Internet. They're used extensively to show sharp tone-mapped images in low resolution so that files are small enough to put on a webpage. JPEG photos are referred to as lossy because they lose information when they're compressed. Each time you open a JPEG file, change something in it using an image processing program, and then save it, the photo degrades considerably, and the information lost is not recoverable.

Moving and opening JPEG photos doesn't degrade them. It's only if you write over them by changing something in them that they degrade, requiring a new copy to be made.

TIFF Images

TIFF files generally are used uncompressed; when you open them, tweak them, and resave them, the quality doesn't deteriorate. In Photoshop, you have an option that compresses TIFFs to make the file size a bit smaller, but not nearly as much as JPEG photos can be. TIFF compression (LZW compression option in Photoshop) is lossy, which doesn't deteriorate when you work with it. It is safest to edit in TIFF.

With the advent of the Raw photo (see the next section), saving as a TIFF file has become less necessary. Now you can tweak your photo in Raw using Adobe Camera Raw (ACR), merge it in an HDR program, tweak it some more in Photoshop's main program, and finally save the photo as a full-resolution TIFF for safekeeping. After that, you can lower the resolution using the Image Size dialog box when you navigate and click on Image > Image Size in Photoshop or Elements. TIFF files have larger files sizes—larger than Raw and JPEG—which means they use lots of memory and storage space.

Raw Images

When your photo is open in Photoshop Raw, you have control of it without having to worry about degradation. More and more digital cameras, from digital Single Lens Reflex (dSLR), point-and-shoot, and the new mirrorless cameras (like Sony NEX 7), are capable of taking Raw photos. Each manufacturer has its own proprietary format so that, unlike JPEG files, Raw files vary in type and have their own filename ending (see Table 29.1). Many HDR programs recognize these proprietary Raw file types so that you will have no trouble opening them in these programs.

TABLE 29.1 Raw File Types

Manufacturer	File Type
Canon	CR2, CRW for older models
Nikon	NRW/NEF, depending on camera model
Kodak	KDC
Sony	ARW/SFF/SR2
Pentax	PTX/PTF
Olympus	ORF
Panasonic	RAW/RW2
Leica	RAW/RWL/DNG
Minolta	MRW
Fuji	RAF

As mentioned in previous chapters, you begin the process of creating an HDR photo or HDR-like photo in Photoshop (tone-mapping) using Raw files because they contain more information.

As a beginning HDR creator, the only thing you have to keep in mind regarding file types is working with your image at the highest resolution possible in TIFF format when tweaking it through different programs.

It's best to begin the HDR process with Raw files; they contain more information, so the programs have more colors and tones to process. However, JPEG and TIFF files work just fine. I recommend converting all your JPEG photos to TIFF right away so they aren't compromised when they are opened, tweaked, and saved before undergoing the HDR treatment.

In most cases, HDR processing programs produce a 32-bit image that you can save for the future (see Chapter 8, "Color Bit Depth"). Converting the 32-bit image to 16-bit format right after processing enables you to tone-map using the maximum color information so color details remain distinguishable (no clipping) throughout the tweaking process. The file remains in 16-bit format throughout the process until the last step in Photoshop's main program (or Elements) when you navigate from Mode > 16-bit to Mode > 8-bit.

A Raw photo is in its raw state. This means the camera does no processing to it; it leaves the job to you in postprocessing. The metadata (the information about all the camera settings in a header file) is always there as long as you work with the Raw photo in Adobe Camera Raw. You can always go back to the way the image was shot without compromising the image—the sharpening

level, contrast, saturation, white balance, tint, color temperature, and so on. Those are the options that appear and that you can tweak when you open Adobe Camera Raw, which is discussed in Chapter 4, "Adobe Camera Raw Photograph Attributes."

A Bit More About Color Bit Depth: The Defining Characteristic of HDR

In the Chapter 4 sidebar, "From 8 Bits/Channel to 16 Bits/Channel in ACR," I described the color bit options in ACR. Also, as mentioned in Chapter 8, "Color Bit Depth," the color bit depth value is the chief indicator as to whether a photo is HDR. Again, if an image is not 32 bit, the image can be called HDR-like or tone-mapped. Color bit depths are the options that you have in HDR programs to set how much color information you want to work with in the program.

Bit depth refers to how much color information is in each pixel. The higher the bit depth, the more editing you can do without compromising the colors.

HDR software can handle large bit depths—larger than what your camera records. The programs combine different exposures into a single HDR 32-bpc (bits-per-channel) image.

When a 32-bit HDR image has been properly tone-mapped, it shows the original dynamic range captured, even when it is saved in an 8-bit image format; however, you cannot view it at 32-bit format because today's monitors can't handle it.

When an image comes up in 32-bit format, the colors can look too dark or too light (see Figure 29.1). You have to remember that this image is only a preview and that 32 bits/channel images have a dynamic range that monitors can't display. If your monitor could show such a range, the image would look a lot more dynamic. Currently, there are no consumer-grade monitors that can display the dynamic range of a 32 bits/channel image.

In Photoshop, you can adjust the preview to see some of the details in the highlights or shadows that are washed out on your monitor.

You can access View > 32-Bit Preview after clicking OK in the Merge to HDR window. Options and the dialog box are shown in Figures 29.2 and 29.3. Tweak exposure and gamma so that you see the smoothest color and no blown highlights (in the signs); then click on the Method option drop-down menu bar to switch to Highlight Compression. Click OK.

Figure 29.1 Images in 32-bit format appear washed out.

Figure 29.2 Photoshop uses an algorithm so that you can preview how a 32-bit image will look if your monitor could handle the extra information.

Figure 29.3 Use the drop-down menu bar to set the highlight compression.

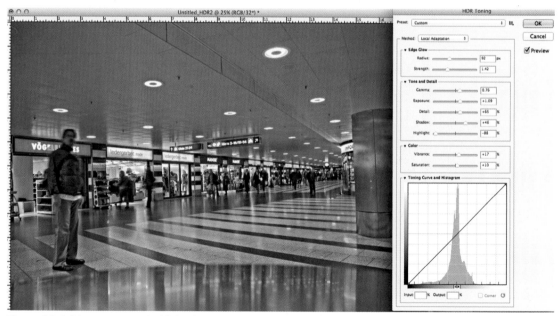

Figure 29.4 You tone-map in 32-bit format; then Photoshop saves the image in 16-bit format.

At this point, you're ready to finish tone-mapping the image. This is a good file to save. It has all the information about the 32-bit file, some of which you can't see now but will be able to when they HDR monitors become available. To tone-map the image, navigate to Image > Mode > 16 Bits/Channel.

> **NOTE**
>
> Your image will stay in 32-bit format while you tweak and change to 16-bit format after you click OK. (Refer to Figure 29.4 on the previous page.) A tone map with sliders and a curve comes up for you to do some final tweaking.

Because you will be opening a TIFF file in Adobe Camera Raw, you have to ensure your Photoshop CS3 through CS6 preferences are set to open TIFF files in that part of the program. To change the preferences, navigate to Photoshop > Preferences > File Handling, where you can view the window shown in Figure 29.5. Click on the Camera Raw Preferences button to get to the window to access TIFF file handling.

Figure 29.5 Click on the Camera Raw Preferences window to control what type of files will open in Adobe Camera Raw.

In the Camera Raw Preferences window, look for JPEG and TIFF Handling (see Figure 29.6). In the TIFF drop-down menu bar, navigate to Automatically Open All Supported TIFFs.

Figure 29.6 Window for handling TIFF files.

Adobe Camera Raw opens your finished HDR-converted image with an 8-bit setting. Change it to 16-bit by clicking on the Adobe RGB (1998): 8-bit link at the bottom of the Camera Raw window. After you click on that link, the dialog box shown in Figure 29.7 appears. Use the drop-down menu bar shown to set the image to 16-bit. Go ahead and work on your image in Adobe Camera Raw and then open it in Photoshop again by clicking on Open Image. The image opens as a 16-bit image so you can do your remaining tweaking in Photoshop with more saved color, tone, and shade detail in the image.

Figure 29.7 Change the image to 16-bit when in Adobe Camera Raw.

If you are going to post the image on the Internet, you can keep the 8-bit setting in Adobe Camera Raw described in the last paragraph because you won't be able to see the difference between an 8-bit and a 16-bit image when it's a low-res compressed JPEG file. If you want to print your image, it's best to keep it 16-bit until you're finished with your workflow; then you can change it to 8-bit depth to print. Color remains pretty much the same whether you print an 8-bit or 16-bit file, even if you print the 16-bit on a 16-bit printer.

Reopen your image in Adobe Camera Raw.

Photoshop Elements has minimal ACR processing. See Chapters 36, "Photoshop Elements Quick Merge," and 37, "Manual Mode" for directions on how to use this feature.

Removing Noise, Halos, and Vignetting

E ven after you have tweaked in high dynamic range (HDR) programs, not every image is going to be a complete HDR work. For many images, you also have to tweak in Adobe Camera Raw (ACR) or Photoshop. This chapter shows you how to eliminate these processing problems so that when you get your results from an HDR program, you know what to do next.

Noise, halos, and vignetting are enemies of HDR photography. Most HDR programs create these beasties because there are three or more images that you are using together, which gives you three or more times the chance of picking up these aberrations when merging them.

Noise is the tiny colorful dots that appear in your image. Vignetting is a black halo around the edges of your image, most noticeable in the corners. It is relatively easy to remove both using ACR.

To remove the vignetting, open ACR and navigate to the Lens Corrections button at the top of the ACR dialog box under the histogram (see Figure 30.1).

Figure 30.1 Navigating to the Lens Corrections tab.

Navigate to the Lens Vignetting slider. Click and drag it to the right to reduce vignetting. Then try moving the Midpoint slider until most of the vignetting disappears (see Figure 30.2).

NOTE
On most images, vignetting is removed with the Vignetting slider only.

Figure 30.2 Tweaking the vignetting using sliders.

To remove the noise, magnify the image to 100% by typing that number in the space at the bottom left of the window. Then follow these steps, using the suggested sliders in the order given.

1. Navigate to the Detail button (Figure 30.3) and click and drag the Color slider to the right to change the noise from colored dots to black-and-white dots.

2. Navigate to the Masking slider and move to the right until you see some of the dots begin to fade. (This works in some images and doesn't in others.)

3. Click and drag the Luminance slider to the right until the noise starts to disappear. If that doesn't remove all the noise, move the Luminance Detail slider to the left.

4. If your image looks a bit blurred, move the Sharpening slider to the right.

5. Look closely at another area of the image (different from the one you've been focusing on while doing these adjustments). If the image needs more tweaking, move the sliders a tad bit more until you get the results you want.

6. Finally, open the image in Photoshop and use the Clone Stamp tool to touch up uneven areas.

Figure 30.3 These tools do an excellent job of noise removal without creating much softness.

Halos are rapid changes in the brightness at the edges of objects in your photo. Ghosting is movement blur. You can remove halos in a number of ways. Decreasing the Strength slider in an HDR program helps to remove the halos; however, it also reduces the HDR effect.

One way to remove halos is to isolate the haloed area with a Selection tool and use the Clone Stamp tool to go over the haloed area. Here are the steps:

1. Select the areas where halos are evident with the Polygonal Lasso tool.
2. Magnify the image to 50% or greater by typing in the number in the lower-left corner of the window.
3. Select the Clone Stamp tool in the Tools palette.
4. Input 2 for Feathering in the top right of the window.
5. Choose a soft brush and select an opacity (top of window next to brush).
6. Carefully outline the areas where there are halos, as shown in Figure 30.4. Go beyond the halos a bit when selecting.

Figure 30.4 Process for eliminating halos in Photoshop.

7. Select a soft-edged brush, a diameter large enough to cover haloed area, and an opacity of about 50% and clone the blue next to the halo by choosing a source point (Option-click on a Mac and Ctrl-click in Windows) in the area closest to the halo with the Clone Stamp tool. Click and drag the Clone Stamp tool in the haloed area.

NOTE

If you find an area that is too dark, navigate to Edit > Fade Clone Stamp and click and drag the slider to the left a bit.

Photoshop CS5 and CS6 (HDR Pro and Working with Settings)

Photoshop CS5 and CS6 are great programs for making high dynamic range (HDR) and HDR-like photographs. Before you use either one to make HDR photographs, it is a good idea to go over Adobe Camera Raw (ACR), which is covered in Chapter 4, "Adobe Camera Raw Photograph Attributes" because some pre- and post-processing may be needed to get that "Wow" photograph.

One of the most accessible and easiest ways to produce HDR photos is to use Photoshop CS5's or CS6's Merge to HDR Pro feature. Creating an HDR photograph from three differently exposed photographs takes just two or three minutes; however, that doesn't mean that the post-processing process is quick and easy. Some shots are merged so well with the algorithm that they can be processed without much additional tweaking, either using tone mapping or editing in Adobe Camera Raw.

To get good results, the first picture you merge to HDR should be taken with three images at +2, 0, –2 EV (exposure value). Also, all three photographs that you will be merging in Photoshop CS5 or CS6 need to be sharp.

To make an HDR image quickly, follow these steps:

1. Navigate to File > Automate > Merge to HDR Pro (Figure 31.1).

Figure 31.1 Navigate to Merge to HDR Pro to begin making an HDR image.

2. Upload the files you want to merge in Photoshop CS5 or CS6 HDR Pro.

3. Click Browse in the Merge to HDR Pro window and navigate to the photos you want to upload. Shift-click on a Mac (Ctrl-click on a PC) to select the images. You can also select Files from the drop-down menu bar in the Merge to HDR Pro window, click Browse, locate the image files you want to upload, and click OK (Figure 31.2).

Figure 31.2 Selecting images for HDR merging.

4. If you have moving people in your image, click on Remove Ghosts and use the drop-down menu bar next to where it says Mode to click on 16 Bit. In Figure 31.3, the ghosts have been removed. Both Photoshop and Photomatix do a superb job of making moving objects that are blurred (called ghosts) sharp. Ignore the rest of the options and click OK. The merging algorithm might not need additional tweaking.

5. Navigate to TIFF format.

6. When your image is finished processing, click on Save As to save it (see Figure 31.4).

7. Select TIFF from the drop-down menu bar for the file format (see Figure 31.5).

8. Tweak in ACR (Figure 31.6). Figure 31.7 shows the final version after the image was tweaked in ACR.

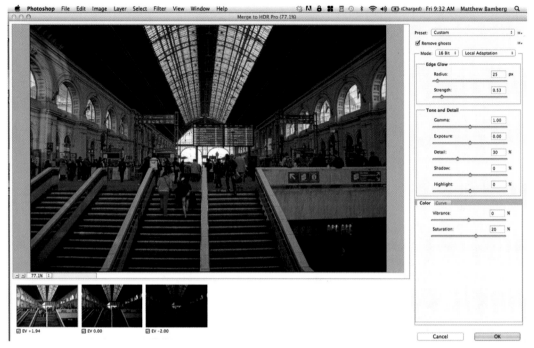

Figure 31.3 Check the option for removing ghosts.

Figure 31.4 Save the file.

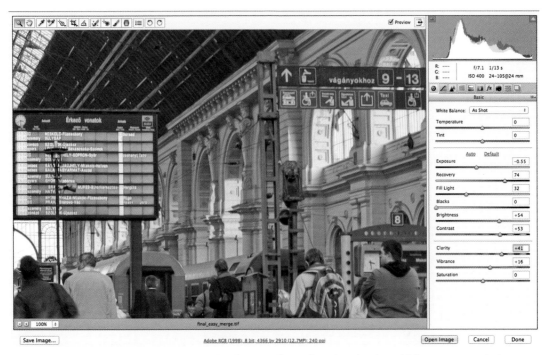

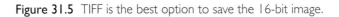

Figure 31.5 TIFF is the best option to save the 16-bit image.

Figure 31.6 Use sliders to tweak in Adobe Camera Raw after changing it to 100 percent resolution.

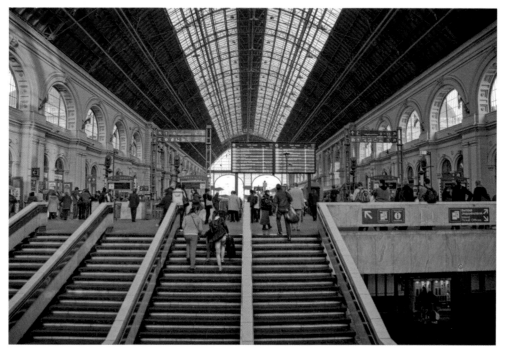

Figure 31.7 Image run through Photoshop HDR Pro (without slider adjustments) and then tweaked in Adobe Camera Raw.

This isn't a bad result. With the exception of the Gamma slider, all the sliders do similar manipulations to Adobe Camera Raw.

Now that you have an idea about the type of results you can get solely from the merging algorithm, you'll learn what each tool does in Merge to HDR Pro in Photoshop.

Let's begin with a new HDR set so you can clearly see what each slider does when you tweak it.

After you have tried merging three photos into an HDR photo without PS HDR Pro tweaks, you're ready to learn about the options in the Merge to HDR Pro window. We'll start with Preset.

Presets

The range of presets covers all the bases, from way overprocessed and stylized to far too flat. The Preset drop-down menu bar is the first option you encounter in the Merge to HDR Pro window. You can start at any of these presets and then use the sliders to tweak your image. I find that Photorealistic is a good place to start because it usually produces an image without halos, blown highlights and/or darkened shadows as some of the other presets do. Your other choices in Photoshop CS5, as shown in Figure 31.8, are Flat, Monochromatic Artistic, Monochromatic

High Contrast, Monochromatic Low Contrast, Monochromatic, More Saturated, Photorealistic High Contrast, Photorealistic Low Contrast, Photorealistic, Saturated, Surrealistic High Contrast, Surrealistic Low Contrast, and Surrealistic.

Figure 31.8 Preset choices in Photoshop CS5.

In Photoshop CS6, the choices include City Twilight, Flat, Monochromatic Artistic, Monochromatic High Contrast, Monochromatic Low Contrast, Monochromatic, More Saturated, Photorealistic High Contrast, Photorealistic Low Contrast, Photorealistic, RC5 (preset by Rafael Concepcion, an expert Photoshop professional), Saturated, Scott5 (preset by Scott Kelby), Surrealistic High Contrast, Surrealistic Low Contrast, and Surrealistic.

When you opt for Photorealistic, the slider values change automatically. Figure 31.9 shows the values right after the photo was merged when Photorealistic is the Preset. The table that follows shows the Photorealistic values for the image before and after tweaking.

Figure 31.9 Settings for Photorealistic image, a good place to begin tweaking.

TABLE 31.1

Slider Adjustment	Value in Photorealistic	Tweaked Value
Radius	26	375
Strength	1.68	1.25
Gamma	1.27	.71
Exposure	0.00	0.00
Detail	46	64
Shadow	−50	0
Highlight	−50	0
Vibrance	30	30
Saturation	10	10

> **N O T E**
>
> There's a tiny bulleted list icon next to the Preset drop-down menu bar. It's the Preset Options icon, which allows you to load and save presets.

Sliders

The sliders in Photoshop HDR Pro aren't meant to be adjusted one at a time. You might want to tweak the Gamma and then tweak the Highlights to get a good balance of color and light in your image.

When I'm tweaking an image, I pay close attention to blown highlights and darkened shadows. One of the main reasons to use an HDR program is to get more detail in your image. If you have blown highlights or shadows that cover your subject matter, you're not really taking advantage of the different exposures and what the software is intended to do: bring forth as much detail as possible.

This section looks at how to tweak the sliders to get a bright and colorful image with lots of details, but one that's not overdone, like you would aim for if you were shooting for a surrealistic or painterly look.

> **N O T E**
>
> As you make changes, increase the resolution to see the image close up and check for aberrations.

Edge Glow

The Edge Glow sliders include Radius and Strength. You don't want to overdo Edge Glow, because it makes your photo appear unnatural. If you tweak just right, Edge Glow adds depth to your image without halos.

The Radius slider controls how much edge and surrounding area will glow.

The Strength slider increases light and contrast as the slider increases. In some images, it creates halos around the edges.

I usually tweak the Tone and Detail sliders before I tweak the Radius and Strength sliders.

Tone and Detail

The Gamma slider adjusts to balance highlights and shadows. The tones and details are greatest when Gamma is set to 1.0. Blown highlights occur if it's too low. Tweak to lessen the differences in brightness where shadows meet highlights, such as where the shadowed area under the roof eaves meets the siding of the house. Stop tweaking when either haloes or flatness appears in the image. Figure 31.10 shows the image with the gamma decreased from 1.27 to .71.

Figure 31.10 Lowering the Gamma creates greater differences between highlights and shadows.

Most of the work that I do has the Gamma slider to the left, which darkens the image substantially. From there, it's all about playing with the Exposure, Strength, and Radius. If I need any sort of additional contrast, I usually tone that up in Photoshop in postprocessing.

The Exposure slider adjusts the brightness and tone of the image. No change is needed in Figure 31.9. This is a well-exposed photo without blackened shadows and blown highlights.

An extreme at either end of the Detail slider produces an image that is too soft (low end) or too flat (high end). In the autumn scene, I increased the Detail level until I saw halos around trees, and then I decreased it until they almost disappeared. The increased detail (from 46 to 64, as shown in Figure 31.11) made the image sharper, allowing the contrast between the shadows and highlights to increase, but not so much that halos were produced. You might not notice a big

difference if the image is well exposed, because the detail is already there. Watch for an increase in blown highlights when increasing the Detail slider. If you see any of those highlights, move the slider back down.

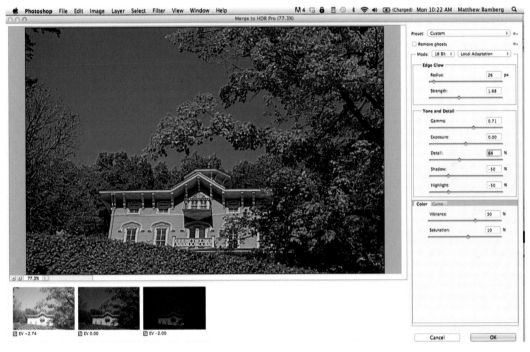

Figure 31.11 The Detail slider is increased.

N O T E

The Shadows and Highlights sliders in Photoshop CS6 are located in the Advanced sliders below the Tone and Detail sliders.

The Shadow slider lets you increase the detail in shadowed areas. It might not look like much has changed in the autumn image, but looking to the right part of the frame (Figure 31.12), you see that there is much more detail in the shadowy areas of the trees, increasing the autumnal feel of the image.

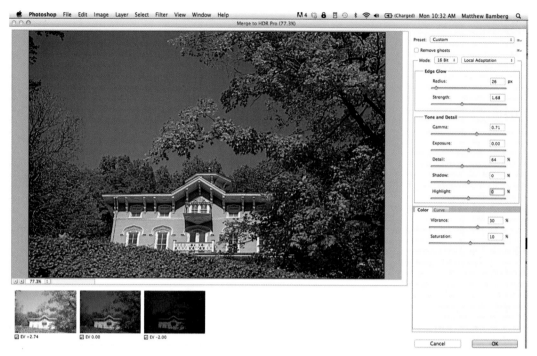

Figure 31.12 Increase shadows to enhance detail; increase highlights to make the house pop out of the image.

The Highlight slider lets you increase light in the background. Blown highlights result if you increase the value too much. In the autumn image, move the Highlight slider up and down to balance color (maintain strong gray in the house) with light (too many white tones result when you increase too much).

Color/Curve (Advanced/Curve in CS6)

Color and Curve are options in Photoshop CS5. Photoshop CS6 has been rearranged a bit so that the Vibrance and Saturation sliders are in the Advanced sliders section with Shadows and Highlights. This change does not affect what the sliders do.

The Color/Advanced sliders should be used sparingly if you want your image to appear real. If your goal is to get an image to look futuristic or surrealistic, then increase the Saturation and Vibrance as much as possible without clipping showing up. Work with the Vibrance first, because it tweaks with the least amount of lost details in the colors.

Vibrance deepens the colors in your image without much clipping by choosing colors that aren't already saturated.

Saturation deepens all the colors, regardless of how saturated they already are. This in turn creates a high risk of clipped colors in the image.

Increase the Vibrance more than the Saturation to avoid blown colors.

When you get some spare time, play around with each of these (Figure 31.13). Then tweak the photo some more with the sliders, which are described below.

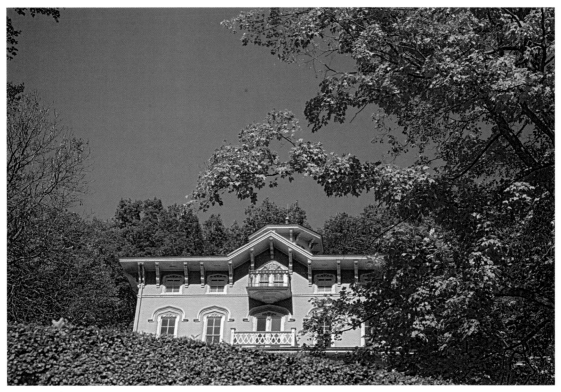

Figure 31.13 Image after tweaking all sliders except the Exposure.

Toning Curve is for fine-tuning the brightness and contrast of your photo. When you click on the Curve tab, you'll find out that it isn't a slider, but a graph. As a beginning HDR photographer, you don't really have to fool with this graph much, because your tweaks with the sliders will be sufficient to produce a decent HDR photograph.

The Toning Curve graph shows your image in terms of brightness, contrast, and zones. The red lines at the bottom of the curve are zones of your photo. You might be familiar with curves from other image processing software that uses them as part of the tweaking process.

You can tweak curves in two ways:

1. Click and drag on the line to create a point (a small rectangle) to move it up or down or to change the overall brightness and contrast of the image.

2. Set anchor points by clicking on the line and then clicking on the Corner option at the bottom of the Curve window. For example, to cordon off part of the line, click on it on one part, click on the Corner option, and then repeat this on another part. You'll only be tweaking one part of the line this way, so you have control over the brightness and contrast of just part of the image.

For more about curves, see the sidebar "The S Curve" later in this chapter.

Use Your Own Presets and Tweak Existing Ones

In Photoshop HDR Pro, you can make your own presets:

1. Choose the preset you want to start with from the Preset drop-down menu bar that is a three-line icon to the right of the Preset drop-down menu bar. In this case, I chose Surrealistic. Note that the sliders change value when you adjust the presets.

2. Click on Remove Ghosts. This causes your Preset drop-down menu bar to switch to Custom.

3. Click on the Preset Options icon and choose Save Preset (Figure 31.14).

4. A Save window comes up with the preset to be saved in the HDR Toning folder (Figure 31.15). Type in a name for your preset in the Save As box at the top of the window, and click Save. In this case, I named the preset "Cloudy at Dusk."

Your presets will now have the preset you just saved in the Preset drop-down menu bar. In this case, Cloudy at Dusk has been added.

You can find all sorts of presets developed by HDR photographers on the Internet. Some work well, and others don't. It all depends on the light and color you have in your shot.

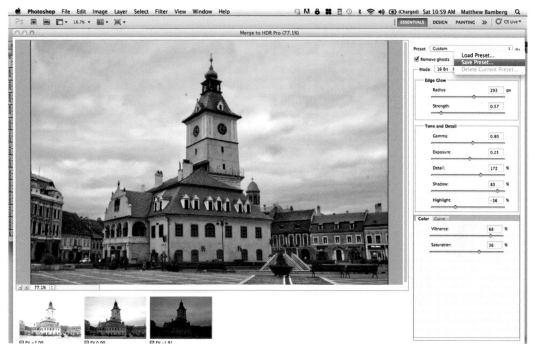

Figure 31.14 Preset chosen and sliders tweaked; ready to save those choices.

Figure 31.15 Preset saved in Adobe Photoshop CS5 > Presets > HDR Toning folder.

NOTE

Presets are saved as .hdt files. HDR experts make many files that you can download from the Internet. When you navigate to the Preset drop-down menu bar and select Load, you have to navigate to the .hdt file when prompted. Save into the HDR Toning folder. Your preset then loads and becomes available with all the others you have in your HDR Toning folder.

Now let's take a look at a different kind of image: a close-up art image that needs a little more work than the last one. See Figure 31.16.

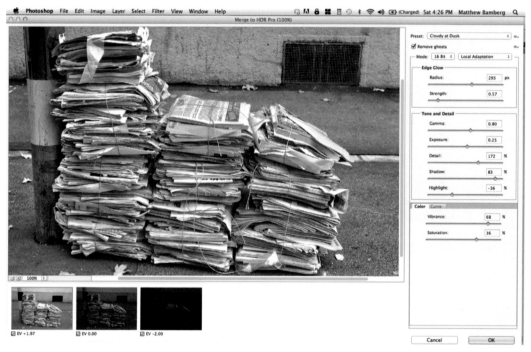

Figure 31.16 Art image with Cloudy at Dusk preset.

I set the preset to the last one I saved—Cloudy at Dusk—so you can see that different presets are needed for different kinds of images. Consider that the changes made from this preset didn't do the trick because this is a close-up in the shade on a cloudy day. There are blown highlights at the tips of the biggest stack of newspapers.

As shown in Figure 31.17, I can decrease the Radius from 293 to 91 to get rid of the blown highlights, without the image becoming too flat from overdoing it. There is still a blue cast to the white tones that needs to be fixed, but I'll get to that later. I leave the Strength about the same.

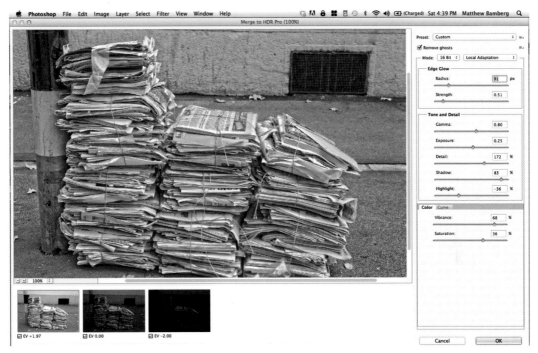

Figure 31.17 Radius is decreased to get rid of the blown highlights.

I decrease the Gamma from .8 to .59 to get rid of the remaining blown highlights (Figure 31.18). If I decrease Gamma too much, the image goes more flat than it already is. Of course, that can be fixed later.

I keep the Exposure the same.

I lower the Detail from 172 to 92 to soften the image a bit, deepening the perspective.

I increase the Shadow from 83 to 100 to bring out details from the grating in the background. I increase the Highlight from −36 to 35; in doing so, I can increase contrast without getting as many blown highlights as I would with the other sliders.

I keep Vibrance and Saturation the same.

There is a blue color cast to some of the papers. I'll be able to reduce that in Adobe Camera Raw. I'll also be able to bring up the contrast a bit in that platform without causing the highlights to blow.

Next, I click OK and then save the resulting image as a TIFF file. I keep the image at RGB 16 because there is more data to work with when I reopen the file in Adobe Camera Raw (Figure 31.19).

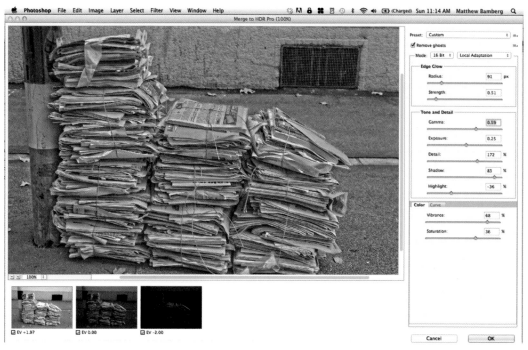

Figure 31.18 Lower the Gamma to get rid of the few remaining blown highlights.

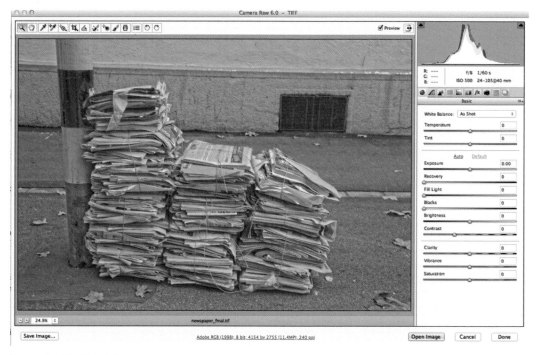

Figure 31.19 Final HDR image brought into Adobe Camera Raw at 16 bit.

Here's what I do in Adobe Camera Raw.

1. I reopen the file so that it opens in Adobe Camera Raw.

2. To warm up the image a little bit, I increase the Temperature from 0 to 8. This removes the blue cast from the photo, but I still have to get the blue cast off the blank paper.

3. To get rid of the blue cast, I navigate to the HSL Grayscale tab. There I click on the Saturation tab and move the Blues slider down to –89, which is almost unsaturated. The blue cast turns nearly white (see Figure 31.20). The blown highlights don't come back when I do this.

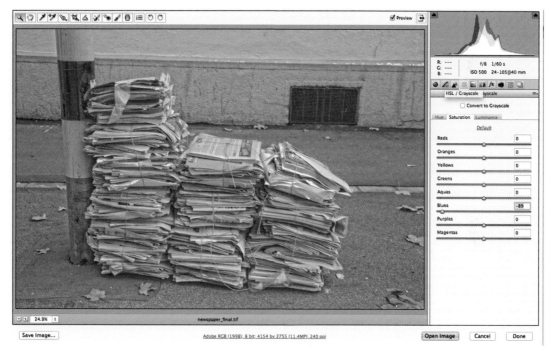

Figure 31.20 Desaturate the blue by navigating to HSL Grayscale > Saturation and decreasing the Blues slider to near –100.

I navigate back to the Basic settings and do the following:

1. Leave Exposure alone.

2. Increase the Recovery to get rid of any blown highlights that may exist.

3. Increase the Black from 0 to 10.

4. Increase the Brightness from 0 to 30. Increasing the Brightness is better than increasing the Exposure because you're less likely to get blown highlights when tweaking it.

5. Increase the Contrast from 0 to 30 so that no flatness remains.

6. Blow up the Resolution when tweaking the Clarity.

7. Leave Vibrance and Saturation alone.

8. Blow the image up to 100 percent to increase the Clarity. My goal here was to make the type on the middle stack of the newspaper sharp.

9. Increase the Clarity from 0 to 70 (Figure 31.21).

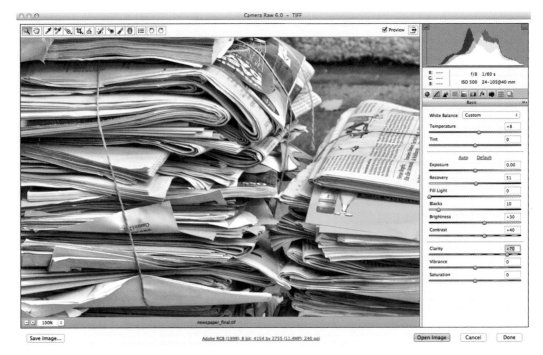

Figure 31.21 Increase the Resolution, and then make the print sharper.

There you have it. The final image is shown in Figure 31.22. Now you understand that when working with Photoshop HDR Pro, you might have to make extensive use of Adobe Camera Raw (see Chapter 4), something you don't have to do as much when working in Photomatix, the platform we'll discuss in Chapter 33, "Photomatix—A Quick Run-Through."

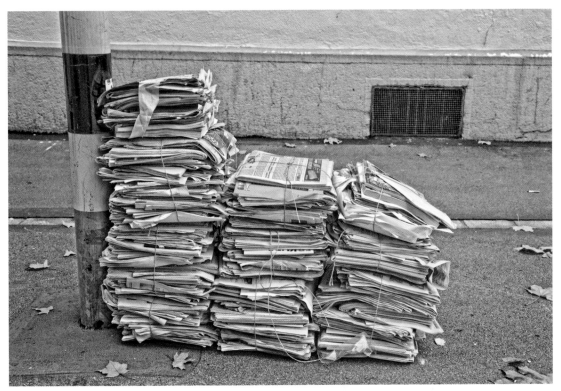

Figure 31.22 Final image after merging in Photoshop HDR Pro and tweaking in Adobe Camera Raw.

THE S CURVE

The curve is where you can have a great deal of control in terms of how the image looks. If you know how curves work in Photoshop, this concept will be familiar to you. On a basic level, curves are best tweaked in the shape of an S by adding three points (they look like tiny squares on the curve line) to the curve and clicking on each to form the S. The S formation adds contrast to the midtones while increasing the shadows and highlights.

Move the lower-left point on the curve (the shadow point) to the bottom-right corner of the first square in the grid. Then click and drag the upper-right point up. Make a point in the middle by clicking somewhere along the middle of the S. (If you want to cordon off an area to tweak without affecting the other areas, make two points anchor points. (See step 2 in the earlier section "Color/Curve [Advanced/Curve in CS6]".) Click and drag the entire S curve until you get an effect you like, or click on one of the cordoned-off points to change part of the image. Figure 31.23 shows one of the many types of S curves you can make. You can add more points if you like, but before you do that, consider the risk of making the changes too complex, which might mean starting anew. When you are satisfied with your S curve, click OK.

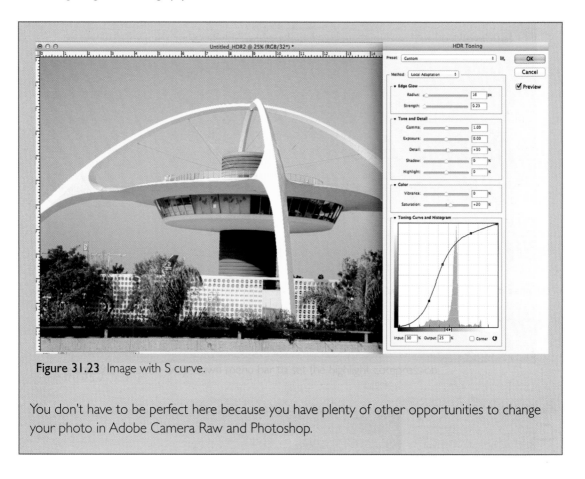

Figure 31.23 Image with S curve.

You don't have to be perfect here because you have plenty of other opportunities to change your photo in Adobe Camera Raw and Photoshop.

Simulating HDR Using a Single Photo

Creating a high dynamic range (HDR)-like image using one photo is possible using any HDR software. The quality of the resulting photo can range from being one that's almost as good as if it were merged with several photos to a noisy unusable one that's no better than the original it was made from.

There are three ways to make an HDR-like photo from a single photo. The first and second involve two methods of tweaking the photo using software. This software is capable of enhancing the photo by adding details in areas of the photo that appear clipped (but have some barely seen details) using tone mapping sliders. The third way involves creating under- and overexposures with Adobe Camera Raw (ACR) and then merging them using HDR merging software.

Photoshop CS5 and CS6 have added a tone mapping tool to their main program. It features the same tweaks that are on the tone mapping tool (including Curves) that you use when you are processing your images with HDR Pro, which is discussed in Chapter 31, "Photoshop CS5 and CS6 (HDR Pro and Working with Settings)."

You can get an HDR effect using one shot by navigating to Image > Adjustments > HDR Toning, which takes you to the HDR Toning window shown in Figure 32.1.

Figure 32.1 The first image starts out at Default, offering the same presets as in HDR Pro.

The tone mapping presets are also shown in that window. They are the same as those you use in Photoshop HDR Pro (see Chapter 31). The HDR Toning option automatically converts your image to 32 bit to give it more dynamic range. In addition to converting your image with the HDR Toning option, an HDR Toning window opens with the same sliders as in Photoshop HDR Pro.

You can begin your tweaks in the Default Preset mode shown in the preceding figure, but you might as well start with the presets that give you the closest match to the type of HDR-like photo you want.

The sliders in the HDR Toning window work well on images that have no clipping (meaning that you can make out all the detail in the highlights and shadows) and only a few presets coming up with a decent image. Many of the tweaks give you unusable clipped or low-contrast images, as when it's set on Surrealistic, shown in Figure 32.2.

N O T E
As soon as you move a slider, the preset's name changes to Custom.

Figure 32.2 Many presets don't work well with single photos.

The presets offer good results for three common types of HDR. Following are the presets I used for tweaking the photo into different styles:

- For a surreal effect without clipping, I started with the Surrealistic preset, and then I tweaked the sliders just a little bit (Figure 32.3).
- For a natural effect, I started with Flat, and then I tweaked the sliders a little bit (Figure 32.4).
- For the monochrome effect, I started with the only monochrome choice that didn't give me halos and clipping, which was Monochromatic Low Contrast (Figure 32.5).

Figure 32.3 Surreal image.

Figure 32.4 Natural image.

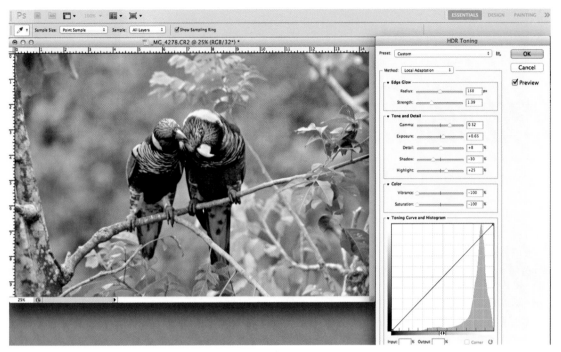

Figure 32.5 Monochromatic image.

N O T E

When in monochrome, tweak the Radius and Strength sliders last.

The values are shown in Table 32.1.

TABLE 32.1 Sample Tone Mapping Values for Different Kinds of Photos

	Surreal	Natural	Monochrome
	Edge Glow		
Radius	150	300	150
Strength	.68	1.66	1.39
	Tone and Detail		
Gamma	.7	.72	.52
Exposure	.25	.3	.65
Detail	70	−3	8
Shadows	15	51	−3
Highlights	−55	−4	25
	Color		
Vibrance	46	0	−100
Saturation	36	0	−100

The Surreal image and values are shown in Figure 32.6.

The Natural image and values are shown in Figure 32.7.

In each image, I concentrated on bringing detail to the shadow and highlighted areas. For the surreal photo, I worked with the Edge Glow settings and then added more detail and color to the shadowed area.

The second way to tweak quickly is to set the Method to Exposure and Gamma, tweaking the sliders that appear. In Figure 32.8, the sliders are tweaked to +0.17 for the Exposure and 0.70 for the Gamma.

The third way is to make three exposures in ACR and combine them using HDR merging software such as Photoshop HDR Pro or Photomatix. In this example, I'll use Photomatix. (See Chapter 31.)

1. Open the Raw photo in ACR.
2. Click and drag the Exposure slider to +2, and save the image. See Figure 32.9.

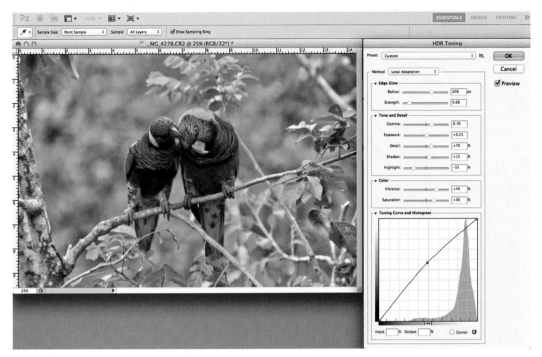

Figure 32.6 Surreal preset with slider tweaks to enhance effect.

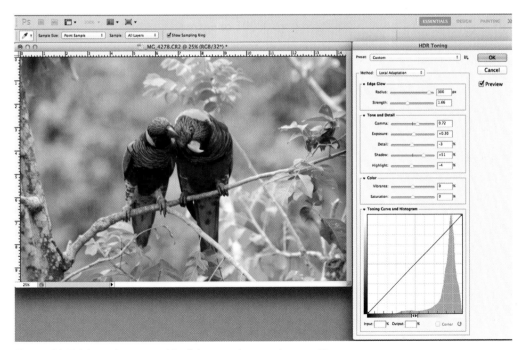

Figure 32.7 Natural preset with slider tweaks to enhance effect.

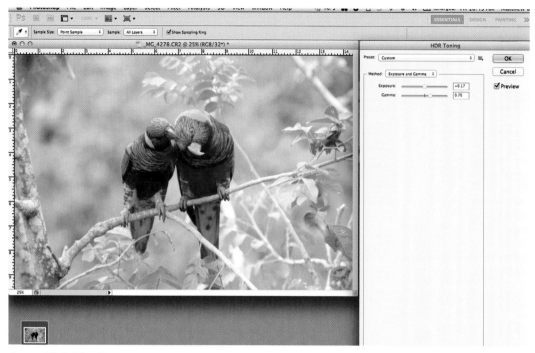

Figure 32.8 The Exposure and Gamma method is a shortcut for tweaking.

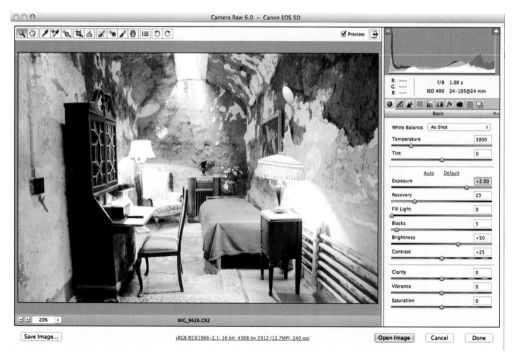

Figure 32.9 Overexposed +2 EV.

3. Open the image again and move the Exposure slider to 0. Tweak the Recovery slider to get more detail into the image, but not too much as to make it hazy. Save the image. See Figure 32.10. You can do anything you want to make the image better when it's merged.

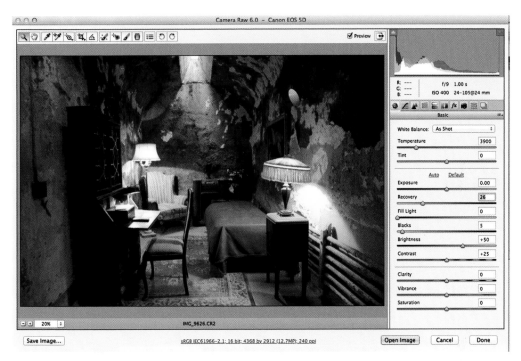

Figure 32.10 Normal exposure with Recovery tweaked in ACR.

4. Open the image for a third time and move the Exposure slider to –2. Then save the image. See Figure 32.11.

5. Open Photomatix and click on Load Bracketed Photos in the top of the Workflow Shortcuts dialog box.

6. In the next window, click on Browse.

7. Navigate to the folder where the three images you made are located.

8. Shift-click (Ctrl-click in Windows) on the images you want to load. Then click Load.

9. Click on OK in the Select Bracketed Photos dialog box.

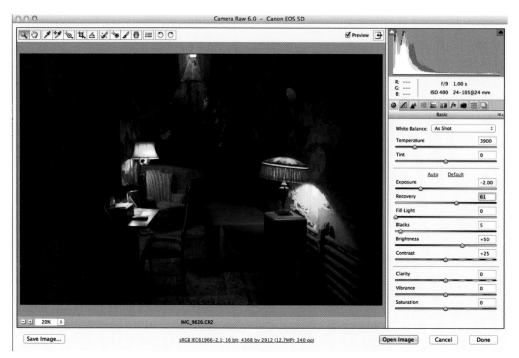

Figure 32.11 Underexposed −2 EV and Recovery tweaked.

10. A message window appears showing the EV for each of the pictures you made (Figure 32.12). Click OK.

11. The next dialog box that appears is Preprocessing Options. Leave options at the defaults. Then click on Preprocess.

12. In the Selective Deghosting window (see Figure 32.13) that appears, click OK.

13. A window appears showing the image with lots of clipping. Ignore this for now and click on Tone Mapping.

14. Click on the Painterly icon in the bottom of the next window (Figure 32.14).

15. Move the Luminosity slider to the left to reduce the noise. You'll learn about all the options in this window in Chapter 34, "Photomatix Options." Click on Process.

The final merged image is shown in Figure 32.15.

Figure 32.12 All images ready to merge after loading files.

Figure 32.13 No selective deghosting.

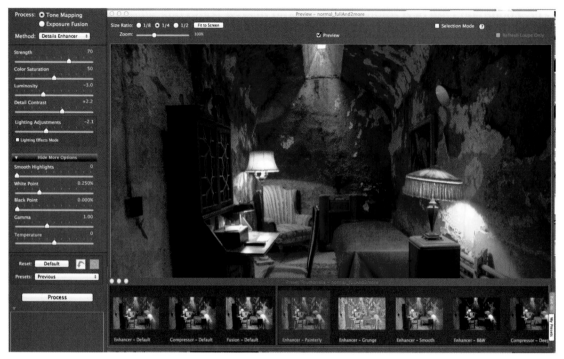

Figure 32.14 The Painterly option is usually compelling.

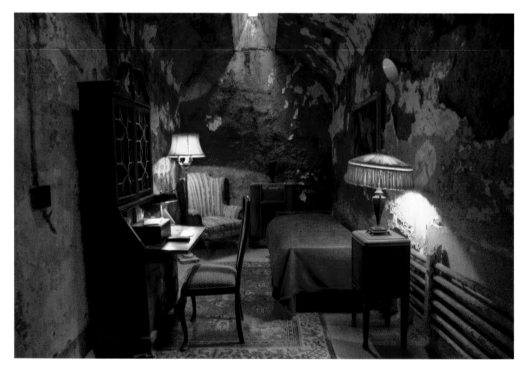

Figure 32.15 HDR-like image using a photo of Al Capone's cell in Philadelphia.

Photomatix—A Quick Run-Through

If you're anxious to see how a photo turns out with Photomatix, you can run through this chapter's steps to get an idea. This tutorial uses none of the many additional bells or whistles the program has, which are described after this section. It is meant for images without moving objects. Making high dynamic range (HDR) photos with images that contain moving objects or subjects is covered in the next chapter.

This section gives step-by-step instructions for making your first HDR photo in Photomatix. Figures 33.1 through 33.3 show the images I will use. As I go through the steps, I'll explain what the options mean in all dialog boxes. It is similar to what we did with the single image in Chapter 32, "Simulating HDR Using a Single Photo."

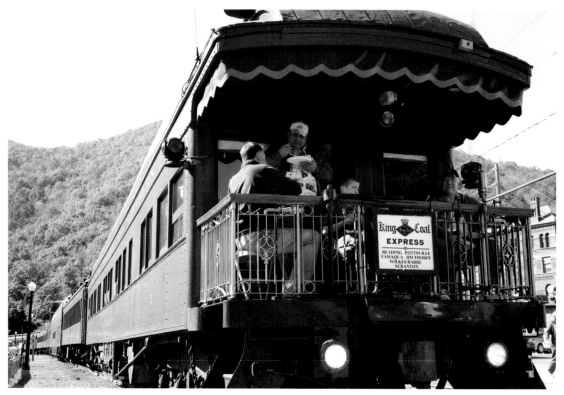

Figure 33.1 Normal exposure to be merged.

NOTE

Photomatix processes the images with an algorithm that uses the details from an overexposed shot for the dark shadows and those from the underexposed shot to give details where the highlights are blown.

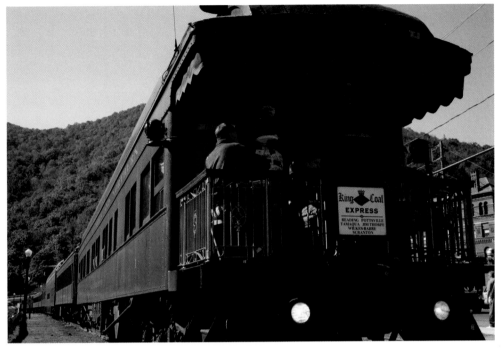

Figure 33.2 Underexposed image to be merged.

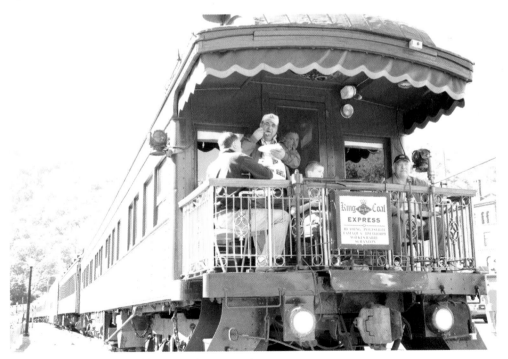

Figure 33.3 Overexposed image to be merged.

1. Click on Load Bracketed Photos in the top of the Workflow Shortcuts dialog box (Figure 33.4).

2. In the Select Bracketed Photos dialog box, click on Choose.

3. Navigate to the folder containing your HDR shots.

4. Shift-click (Ctrl-click in Windows) on the images you want to load, as shown in Figure 33.5). Click Load at the bottom of the Load Photos Taken Under Different Exposure Settings window.

Figure 33.4 Window for loading photos.

5. In the Select Bracketed Photos dialog box, check Show Intermediary 32-Bit Image (Figure 33.6). You do this because you want the program to produce a 32-bit image that you'll save (but not use) for the future when computer monitors can handle that bit size. Click OK.

6. The next dialog box that appears is Preprocessing Options, as shown in Figure 33.7. These options usually aren't changed much from one set of shots to another. To merge the photos here, choose the defaults, which are the ones that appear in the Preprocessing Options dialog box. We'll talk about each default in the next chapter.

7. Click OK in the Preprocessing dialog box to proceed to the Selective Deghosting window.

8. In the next window, click and drag around the ghosted subjects, as shown in Figure 33.8.

Figure 33.5 Use the Show Icons option when navigating to the HDR photos you want to use.

Select bracketed photos.

Either navigate to your photos via the "Browse..."
button or drag-and-drop image files from the Finder.

IMG_9818.CR2
IMG_9817.CR2
IMG_9816.CR2

Browse...

Remove

☑ Show intermediary 32-bit HDR image

Cancel OK

Figure 33.6 Click on Show Intermediary 32-Bit Image.

Figure 33.7 Preprocessing options.

Figure 33.8 Click and drag around ghosted subjects.

9. Click on Preview Deghosting to see the effects of your changes (see Figure 33.9). If the ghosts have been removed, click OK. If not, click on Return to Selection Mode (the screen changes back to where it was in step 5) and Ctrl-click (right-click in Windows) inside the selection. A pop-up appears, in which you're given the option to remove the selection. Click on the selection, and it disappears. Start over again. When you are satisfied with the ghost removal, click OK.

Figure 33.9 The corrections are good; no more ghosts!

NOTE

Before you click the Tone Mapping button, you have the option to save the 32-bit image in HDR format, which is the default. If you want to edit your photo again from this point, save it.

10. The next window is the image in an unprocessed state, not viewable with today's monitors. You might want to keep it, though, because monitors that can handle it might be just around the corner.

11. Click on Tone Mapping to see an image adjusted for today's monitor (Figure 33.10). Figure 33.11 shows what Photomatix comes up with after tone mapping to make the colors on the 32-bit image visible.

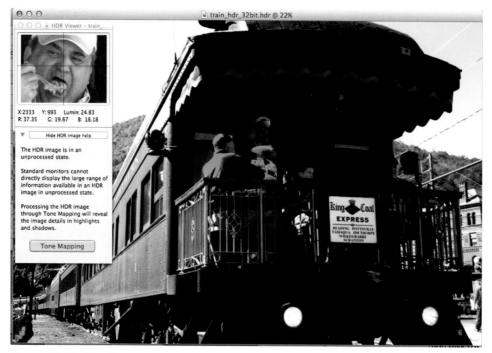

Figure 33.10 Click Tone Mapping to see the image.

Figure 33.11 Image after processing without tweaks to sliders.

12. Look at the image. Leave all sliders at their default. Choose a thumbnail sample (a preset) from the bottom of the window, and then click Process. I chose Enhancer Smooth. Click Process.

Figure 33.12 shows the tone-mapped image without tweaking in Photomatix or ACR.

Figure 33.12 Enhancer Smooth is a preset Tone Mapping option.

NOTE

Some presets contain significant aberrations. It just depends on the number of photos you've used in the merge and their exposures. You can work with the sliders to improve your image.

13. After you click Process, the finished image appears. Go ahead and save it as a 16-bit TIFF file. After you save it and rename it, the final image is automatically opened in ACR for further tweaking.

You probably like the Smooth effect if you're into a natural-type HDR photo. If not, it's my guess you picked another choice. Whatever you picked, now is the time to think about how to repair the halos and blown highlights in the image. In the next chapter, I'll show you how to use some options in Photomatix and ACR.

CHAPTER 34
Photomatix Options

Photomatix offers several steps to preprocess your high dynamic range (HDR) photo. The photos you're merging will take on a number of different characteristics as you preprocess them by making choices in the Preprocessing Images dialog box. The options you have for this process help make the merging effective for the photos you have uploaded. After you have loaded your photos, you're taken to the Preprocessing dialog box, which has a set of important preprocessing options. The check box options include Align Source Images, Remove Ghosts, Reduce Noise On, and Reduce Chromatic Aberrations (see Figure 34.1). Below the check box options is the Raw Conversion Settings drop-down menu bar.

Figure 34.1 Photomatix Preprocessing Options.

Align Source Images

Align Source Images aligns any shot that it is out of alignment from camera shake or from pressing the shutter release button when you've used a tripod. I recommend using it on all shots.

> **NOTE**
>
> If you are merging three different exposures of the same photo (see Chapter 32, "Simulating HDR Using a Single Photo") you don't need to click on the Align Source Images box.

Here are the options for Align Source Images:

- **By Correcting Horizontal and Vertical Shifts**—This is helpful when you've used a tripod with a cable release or used the timer.
- **By Matching Features**—This is good for handheld shots when the camera shake is present in every direction, no matter how still you think you were.

- **Include Perspective Selection/Maximum Shift**—These options deal with the extent to which converging lines or lens distortions are the result of slight mismatches from image to image. They're helpful for architecture shots. You set the Maximum Shift slider to the percentage of misalignment you want to correct for.

 I usually set the Maximum Shift slider to a value less than 9. (The default value is 6%.) If the image is any more than 10% out of alignment, the program stretches the subject/object so it looks abnormal.

- **Crop Aligned Images**—Use this for handheld shots. Handheld shots have more of a chance of being misaligned, leaving extra space from one or more of the photos from realignment. When you select the Crop Aligned Images option, you are saving a step that would have to be done upon completion of the HDR.

Remove Ghosts

Remove Ghosts is an effective way to include moving subject/objects in your image without the appearance of seeing double. Ghosts are similar to the pleasant motion blur you see in images taken with long exposures except they have gaps in them from the time the camera stopped taking one picture and started taking another. Photomatix is effective in making ghosts meld from multiple figures or objects into a single figure or object.

There are two ways to remove ghosts:

- **With Selective Deghosting**—This is recommended. When you select this option, the next window is programmed to remove the ghosts by clicking and dragging a white circle around them. It is easy to use and effective to merge any ghosted areas of your image that you have selected.

- **Automatically**—Automatically detects ghosted zones in the merged image. The Detection drop-down menu offers High and Low options, which tell Photomatix which pixels are ghosted. High means that the program uses high detection—even small amounts of ghosting are detected. Low means that significant levels of ghosting are detected.

In most cases, I choose the option With Selective Deghosting, which works really well. There is an example of the process in Chapter 33, "Photomatix—A Quick Run-Through."

N O T E

When you use Selective Deghosting, you might change your mind and select something to deghost and then decide you want to remove it. To do that, Ctrl-click (right-click in Windows) inside the selection. A pop-up appears giving you the option to remove the selection. Click on the selection, and it disappears.

Reduce Noise

Reducing noise is an important task in producing HDR photographs. At this time, the HDR programs are not all that efficient at eliminating noise. You can try to reduce it further in Adobe Camera Raw (ACR). See Chapter 30, "Removing Noise, Halos, and Vignetting."

Here are the options for reducing noise during preprocessing:

■ **Reducing Noise Options**—This option removes noise; however, after your photo is processed and merged, noise remains. (See the next sidebar, "How Well Does Photomatix Eliminate Noise?") Go ahead and check this option. You can use the noise reduction option to select for which exposure you want the noise reduced in the Reduce Noise On drop-down menu shown in Figure 34.2. Note the slider under the option. You can increase that well past 100% if there is a lot of noise.

Figure 34.2 You have a choice of exposures in a drop-down menu bar in which to remove noise.

HOW WELL DOES PHOTOMATIX ELIMINATE NOISE?

The merged photo uses the pixels for the underexposed photo in the areas of blown highlights in the normally exposed photo. It also uses the pixels from the overexposure to replace darkened shadows in the normally exposed photo.

A noise problem develops when the merged photo doesn't get enough color information from the overexposed photo (the shot with the exposure compensation set to −2 EV, for example) to replace heavily shadowed areas. See Figure 34.3. In other words, although much of the photo is lighter from the overexposure, there are still some heavily shadowed areas covering up details. When the merged photo in an HDR program is tweaked to enhance the details in its shadowed area, the program adds noise if your original overexposed shot hasn't lightened the heavily shadowed areas enough to bring out the details.

Figure 34.3 Circle indicates the area of the merged image that wasn't exposed adequately to bring out the details.

Figures 34.4 and 34.5 illustrate just how effective the noise removal is in Photomatix.

Figure 34.4 Abundant noise from dark areas of the overexposed photo when photos are merged.

Figure 34.5 Maximum noise removal results in the color noise changing to black and white.

Reduce Chromatic Aberrations and White Balance

The Reduce Chromatic Aberrations check box and White Balance drop-down menu bar require only a simple explanation because there are no additional options for the former and you needn't be concerned about the latter at this point in the HDR preprocessing.

These are multicolored edges of objects that sometimes appear in your photo. Photomatix does an excellent job of removing them. Always check the Reduce Chromatic Aberrations box, which is shown in Figure 34.1.

There's no need to fool with White Balance because you can easily tweak the White Balance with the White Balance slider in ACR if you have Photoshop. You can use the Temperature and Tint sliders in ACR to tweak instead of the White Balance slider. (See the end of Chapter 33.) Navigating to ACR happens automatically when your image is deposited in the ACR window after you save the final tone-mapped image.

Thumbnail Presets, Adjustments, and Preview

After preprocessing is finished, you'll process an HDR-like image with the Adjustments and Preview windows. (See Chapter 33 for the exact steps you'll follow with an actual photo.)

Processing the image involves working with three windows—Thumbnail Presets, Adjustments, and Preview—that appear after preprocessing. At this point, you are into the gut of the program, performing the most important operations for a successful HDR-like image.

Thumbnail Presets

After you finish selecting and processing your preprocessing options, you can tweak your photo in a multitude of ways by clicking on one of the thumbnails in the Thumbnail Preset window. The first thing you'll probably want to do is fool around with the preset thumbnails.

In Figure 34.6, I chose the Black and White Enhancer to show you what happens when you click on a Thumbnail preset. By clicking on the Enhancer-B&W in the Thumbnail Presets window, the image displayed in the thumbnail is enlarged and presented in the Preview window. In the Adjustments window, the sliders are preset to create the image in the Preview window.

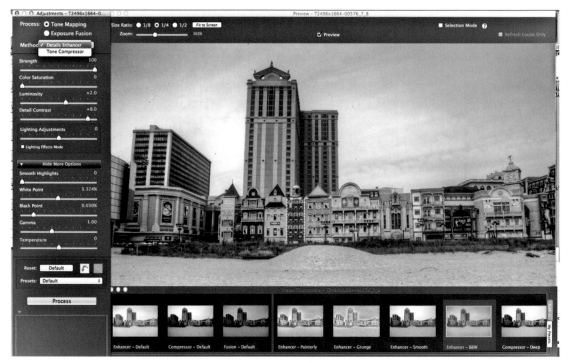

Figure 34.6 The Black and White Enhancer is one choice of many in the Thumbnail presets window.

N O T E

You have a choice between two merging methods—Details Enhancer and Tone Compressor—when the Tone Mapping process is selected from the Method drop-down menu bar.

The next Thumbnail presets I'll illustrate are Painterly (one of my favorites) and Grunge. Painterly (Figure 34.7) has less of a noise problem than Grunge does. See Chapter 30 for the detailed step-by-step process that takes care of all the noise.

Figures 34.8 and 34.9 show you that there is a big difference in the noise levels of Grunge and Painterly.

Figure 34.7 Car processed in Painterly.

Figure 34.8 You have to deal with more noise in a Grunge preset.

Figure 34.9 If you want less noise, try the Painterly preset.

GETTING RID OF HALOS DIRECTLY IN PHOTOMATIX

Chapter 30 described how to get rid of the halos in Photoshop. You have to do this if you have already merged the image and converted it to 8 bit. Doing so is easy if you replace the haloed area with an exposure that doesn't have halos.

You can remove halos by following these steps:

1. Click on Selection Mode in the top-right corner of the Adjustments window.

2. Choose the Normal Lasso (you have a choice of a Polygonal and Magnetic Lasso also) from the drop-down menu bar in the top-right corner of the Adjustments window, next to where you checked Selection Mode.

3. Click and drag your selection, as shown in Figure 34.10. Don't worry about being exact, because in the next step you'll work with the edges. You can select only once. If you make a mistake, you have to start over by selecting again, clicking on the first point of the new selection (at that time the new selection begins and the old selection disappears), and dragging the dashed line around the new area you want to select.

Figure 34.10 Select one area at a time.

4. Click on Attach to Edges under Selection Mode in the top-right corner of the window. (This won't work with the Magnetic Lasso tool.) Photomatix takes the selection to the edges in different amounts depending on what you set the Size and Contrast drop-down menu bars to. In Figure 34.11, I choose 30 px (amount selection will move) and low contrast (contrast between selection location and the edge of the surface it's supposed to hit). The result may not please you in some spots, but there's no need to worry. When you replace the image, usually with an underexposure, the remainder of the merged image and the underexposure are enough alike that you won't notice the erratic spots of selection.

Figure 34.11 Choose an exposure that you want your selected area to change to.

5. Right-click (Windows) or Ctrl-click (Macintosh) to choose which exposure you want to replace the selected area with (Figure 34.12). Most of the time you'll want a deep blue sky as a replacement, which makes the underexposure a good choice.

6. Repeat steps 3–5 for additional areas in the image. You can see in Figure 34.13 that the sky on the right needs some work. To fix it, you just repeat the steps. This task is a bit different from Photoshop and other image processing programs in which you can select everything at one time by holding down a key on the keyboard and continuing with your selection.

In the figures in this sidebar, you'll also notice that the man's shirt on the left side of the back of the train has blown highlights. You can fix these by selecting that part of the shirt and going through steps 3–5.

Figure 34.12 You have a choice in which exposure you want to replace a selected area.

Figure 34.13 Selected area replaced with what's in the underexposed image.

Adjustments Window

The Adjustments window in Photomatix has a variety of options that are chosen by selecting either Tone Mapping or Exposure Fusion. The former has two methods: Details Enhancer and Tone Compressor. The latter has five methods: Fusion-Adjust, Fusion-Intensive, Average, Fusion-Auto, and Fusion-2 Images. I'll discuss Tone Mapping because it is most closely related to an actual HDR image. Exposure Fusion is discussed in Chapter 35, "Exposure Fusion."

Tone Mapping has two methods that are accessed in the Method drop-down menu bar: Details Enhancer and Tone Compressor (refer to Figure 34.6). The first is the most useful because it creates such dramatic images using the local contrast. The second adjusts the image globally, meaning that all the contrast in the image is tweaked at once without taking the local contrast (contrast of specific areas of the image) into account. This makes the result free from noise and halo artifacts but lacking in local details and contrast.

I'm going to explain Tone Mapping and its options/sliders starting with Grunge presets. Figure 34.14 shows the train image sliders set to default after clicking the Grunge preset. (The default for the image is Enhancer-Default.) Defaults are the settings that Photomatix calculates during the image merging process. The sliders are as follows:

Figure 34.14 This image is the default tweak for the Grunge preset in Photomatix.

■ **Strength**—When you're in the Grunge preset and you increase the Strength slider, you get more enhancement, but you also get more halo and noise (see Figure 34.15).

Figure 34.15 Decreasing Strength eliminates halos.

NOTE

You have to decide whether you want to eliminate halos by decreasing the Strength (also the surreal HDR effect) or tweaking in ACR or Photoshop.

■ **Color Saturation**—This affects the intensity of color. Increase the slider for deep color, or decrease it for more subtle color. To change an image to black and white, set Color Saturation to 0. In Figure 34.16, the saturation was lowered from 80 to 64. You usually have to lower the Color Saturation from the default, especially if you want the image to have any connection to reality.

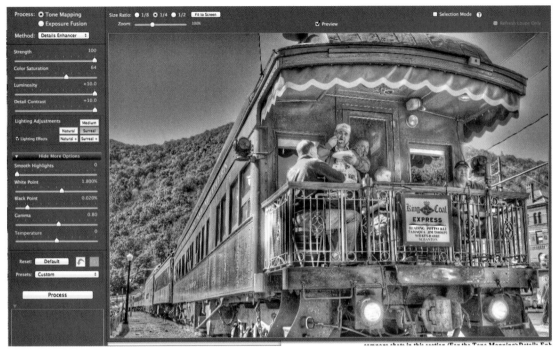

Figure 34.16 You often have to decrease the Saturation because HDR images often are oversaturated by the software.

- **Luminosity**—Increase this slider, and you decrease contrast, removing shadowed areas (black tones). Decrease this slider, and you increase contrast, adding shadowed areas (black tones). An example of lowering the Luminosity from 10 to 6 is shown in Figure 34.17. Notice the increased shadows/black tones. You have to be careful here because lowering Luminosity increases the halos. When you've chosen the Painterly preset, you have too much shadowing. Increase the Luminosity to decrease the shadows, lightening your photo a bit.

- **Detail Contrast**—This controls the amount of contrast applied to detail in the image. Move the slider to the right to increase the contrast of the details and give a sharper look to the image. Note that increasing the contrast also has a darkening effect. Move the slider to the left to decrease the contrast of details and brighten the image.

 If you look at Figure 34.18, you'll find that the Strength for surreal images is always set to 100 (the default). Tweaking Contrast does nothing for a surreal image, which was decreased from 10 to 3, except add blown highlights. See Figure 34.19. So if you want a more surreal-looking image (as in Grunge), leave Contrast at 10. This isn't the case for other presets, though.

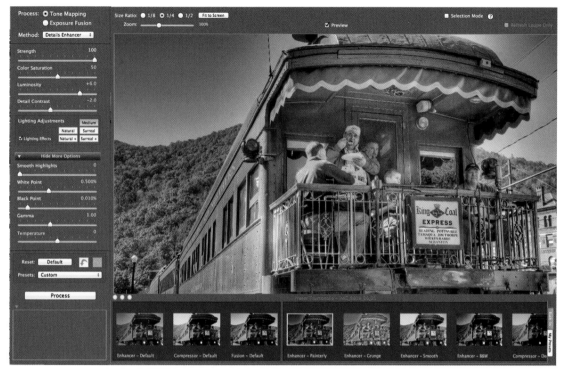

Figure 34.17 The Luminosity slider is good for adding or removing shadows.

If you opt for Painterly, you get a little lightening when you decrease this slider at the expense of losing a bit of detail in the highlights from –2 to –6, as shown in Figures 34.20 and 34.21. (Notice that there's more detail in the man's shirt when the Detail Contrast is higher.)

When you're using the Painterly preset (see Figure 34.22), decreasing the Detail Contrast improves the image significantly, so all you have to do is get rid of the halos. Figure 34.23 shows you the improved look that results when you decrease the Detail Contrast from 6 to –2. The change causes high-contrast fill light to make the people on the back of the train sharper and brighter without blowing highlights. (This is as opposed to the low-contrast results that you get from increasing the fill light in ACR, which makes the image brighter, but at the expense of haziness.)

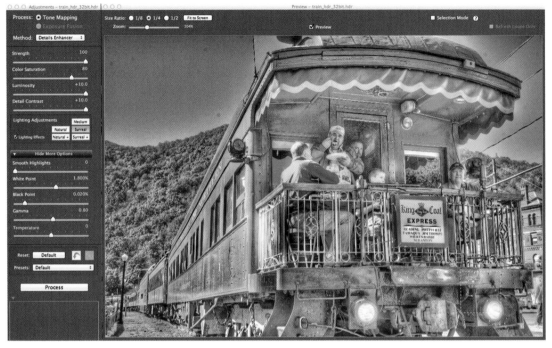

Figure 34.18 Strength for Surreal preset is always set to 100.

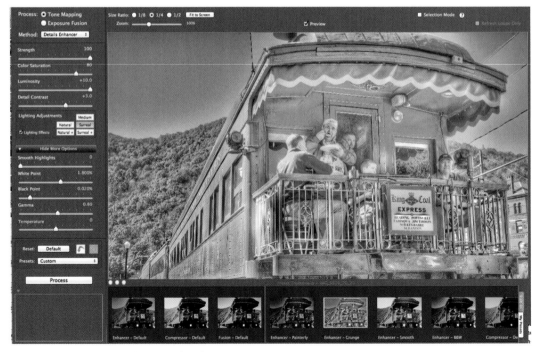

Figure 34.19 Lowered Contrast for Grunge preset.

Figure 34.20 Detail Contrast before tweak.

Figure 34.21 Detail Contrast after tweak.

Figure 34.22 Photomatix default for the Painterly preset.

Figure 34.23 Decreasing the Detail Contrast slider can improve an HDR image.

■ **Lighting Adjustments**—You can tweak the placing of lighting when Lighting Effects mode is not checked. Decrease to add light from the center outward. Increase to darken images from the middle outward.

If you click on Lighting Effects mode, you see the following button options and a description of the light they produce. These buttons affect the light the same way regardless of your preset for an image; however, the results vary considerably among pictures, depending on their lighting.

The Lighting Adjustments buttons consist of options that vary the lighting of your image to simulate an additional effect. They work independently of the Thumbnail Presets. The order of enhancement for details from least to most is Natural, Natural+, Medium, Surreal, and Surreal+.

- **Natural**—Normal lighting and exposure. See Figure 34.24.

Figure 34.24 Natural.

- **Natural+**—Balanced enhanced lighting, leading to a lighter image; high risk of blown colors. See Figure 34.25.

Figure 34.25 Natural +.

- **Medium**—A small amount of light added to enhance details; at risk for blown colors (Figure 34.26).
- **Surreal**—More light added and redistributed to enhance detail; some risk for blown colors (Figure 34.27).
- **Surreal+**—A lot of light added and redistributed to enhance detail; little risk for blown colors (see Figure 34.28).

Figure 34.26 Medium.

Figure 34.27 Surreal.

Figure 34.28 Surreal+.

Preview

The Preview window is the largest of the three windows that open for processing an image. Every time you tweak a slider or click a preset, the image in the Preview window changes. It also changes (along with the slider values) when you click on a Thumbnail preset.

> **NOTE**
> Images shown in the Preview are not HDR because they aren't 32 bit. They are merely a simulation of HDR according to the number of colors on your monitor.

More Options

You access the next sliders by clicking on the Show More Options arrow.

Only increase the amount in the Smooth Highlights slider until the noise and halos are at a minimum (Figure 34.29). Any more than that results in blown highlights.

Figure 34.29 Smoothing increased to 15 removes some of the haloing.

Black Point and White Point tools are used to add details to nearly blown highlights and add details to nearly black shadows. When using either tool, pick out a spot in the image that has either blown highlights or darkened shadows and move sliders a bit until the area has more detail. The White and Black Point sliders work the same way regardless of the preset you are tweaking.

> **N O T E**
> Tweak Black and White points together—first one, and then the other.

White Point, initially in the Grunge preset, was set to default, which is 1.80%.

If you decrease White Point to 0, the image darkens. Figure 34.30 shows the darkening that took place after lowering it to around .12%. I moved the slider slowly while looking at the gold railing, which was almost blown out. I moved the slider until most of the clipping was removed (except for the man's shirt, which can be corrected when replacing areas of HDR shot with one of the single shots discussed earlier in the chapter). If you move the slider the other way, the image lightens with some blown highlights and reduces shadow clipping. Because I've tweaked this, I'll move onto tweaking the Black Point setting to balance the light in the image.

Figure 34.30 Added detail to the gold railing where highlights have been clipped.

Black Point does the opposite of White Point: lightening by clicking and dragging the slider to the left and darkening when the slider is moved to the right (reduces highlight in an image by watching an area of nearly blown highlights and moving it slowly to the right). Now I'll tweak the Black Point of the image with the White Point set to .12 to lighten it a bit. Figure 34.31 shows the image tweaked to make it lighter. The Black Point value of the merged image ended up being 0. That happens sometimes with Grunge photos. I did this after I tried other ways of tweaking, such as moving the Black Point slider before moving the White Point slider. Notice that there's no value to the Black Point and that the image doesn't have many darkened shadows (without detail).

Figure 34.31 White Point was tweaked before Black Point.

Gamma works with the midtones, changing the Brightness and Contrast simultaneously. Increase Gamma by moving the slider to the right, and you'll decrease Contrast while brightening the image with a hazy white tone covering the entire frame. Decrease Gamma by moving the slider to the left, and you'll get a darker image with increased contrast at the expense of black shadows. Initially, the image is set at about .8, which is good for the initial default Grunge image.

As in ACR, the Temperature slider changes the warmth of the image. Move the slider to the right and you get red tints, which create a warm image. Move it to the left and you get blue tints, or a cooler image. I rarely use the Temperature slider because Photomatix automatically tweaks it.

Advanced Options

Photomatix offers some advanced options that can significantly enhance your photo. Take a look at the image in Figure 34.32, which is tweaked with the default values. Use this photo to compare the upcoming tweaks in Figures 34.33 through 34.35.

Figure 34.32 Photomatix advanced options.

Following are the advanced Photomatix options and settings:

- Micro-smoothing 3.0
- Saturation Highlights 0
- Saturation Shadows 0
- Shadows Smoothness 0
- Shadows Clipping 0

Tweaking effects include the following:

- **Micro-smoothing**—When decreased, it increases the surreal effect of any photo. See Figure 34.33 for the effect of decreasing this slider to 0.

- **Saturation Highlights/Shadows**—When decreased, highlights become less saturated. When increased, highlights become more saturated. Figure 34.34 shows how the train's yellow becomes more saturated when it is increased to the maximum (10) because it is a part of the highlights. When Saturation Shadows is increased, the darker colors become more intense. In this picture, the yellow becomes more saturated because it contains shadows, and the "Pullman" lettering becomes very saturated. Otherwise, there isn't as much change as when you tweak the highlights.

Figure 34.33 Micro-smoothing decreased to 0 increases surreal effect.

Figure 34.34 Saturation Highlights increased to 10.

- **Saturation Smoothness/Clipping**—Shadow Smoothness can be ignored; it doesn't change shadows enough to be noticeable. Increasing Clipping increases the shadowed area. In Figure 34.35, the Shadow Clipping has been increased to 81, making the shadowed areas darker and larger.

Figure 34.35 Increasing Shadow Clipping darkens shadows.

- **Tone Mapping—Tone Compressor**—Because the Tone Compressor doesn't take into account the local areas of the photograph (it tweaks all of the photo at once), you don't get as much of a dramatic effect as you do when tone mapping. Nevertheless, the result is better than a single normal exposure.

Before I begin to explain and tweak the Tone Compressor sliders, look at the three images that will be used for the tone compression in Figures 34.36 through 34.38.

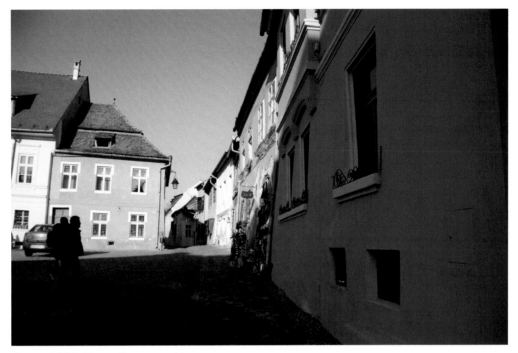

Figure 34.36 Normally exposed image.

Figure 34.37 Underexposed image.

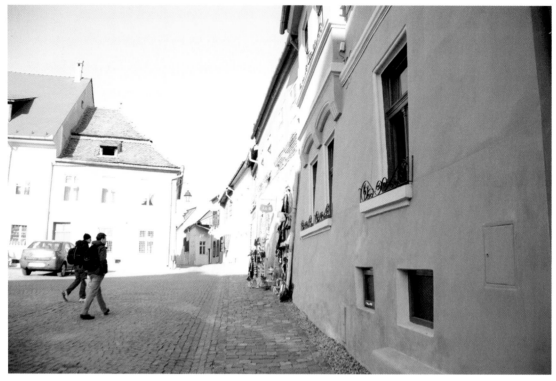

Figure 34.38 Overexposed image.

Figure 34.39 shows the image before tweaking, which will be used to compare how the sliders have changed.

Brightness lightens when you move the slider to the right and darkens when you move it to the left. The nice thing about this slider is that it doesn't blow highlights when you lighten. Figure 34.40 shows the effect of the brightening.

Tonal Range Compression does pretty much the same thing as the Brightness slider for all practical purposes.

Contrast Adaptation is kind of a subtle fill light. Figure 34.41 shows when the value is set to 10.

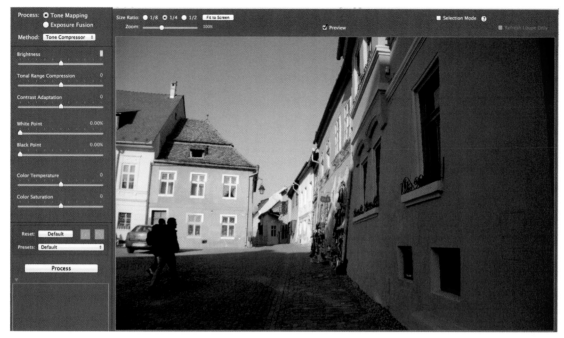

Figure 34.39 The default sets all sliders to 0.

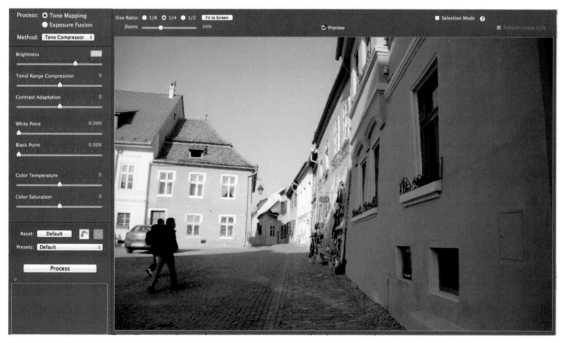

Figure 34.40 Image could be a little brighter than the default, so brightness was increased.

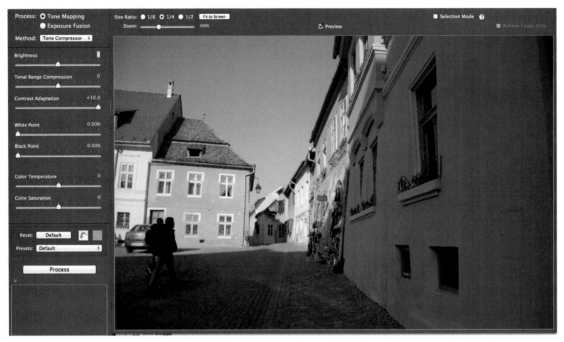

Figure 34.41 Contrast Adaptation adds light to shadowed areas.

The White Point lightens when you move it to the right. There's no need to set it with this image, because it blows highlights easily. The Black Point darkens when you move the slider. The darkening occurs mostly in the shadowed areas, which isn't much help in improving the image.

Color Temperature and Color Saturation perform the same function that they do when tone mapping.

Overall, the sliders don't do much to improve the image.

> **NOTE**
> There are no presets for Contrast Adaptation.

WORKING WITH BLACK AND WHITE

Figure 34.42 shows the drama of a black-and-white HDR-like photo (tone-mapped). To make a black-and-white photo, just click on the Enhancer B&W thumbnail in the Preset thumbnails window (Figure 34.43).

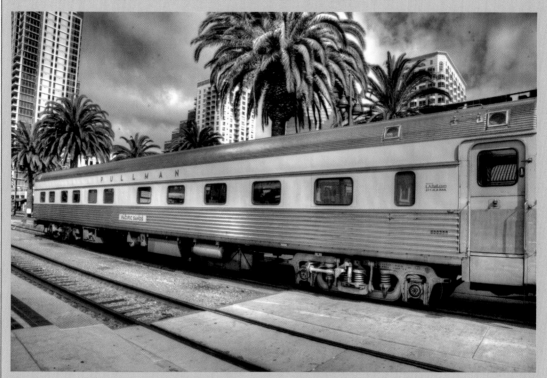

Figure 34.42 Final black-and-white image.

After you choose a preset, you can tweak the sliders. For the image in Figure 34.43, you don't have to do much if you like just a bit of surrealness. You can tweak any of the sliders for different effects. The exception is the Saturation slider, which needs to remain at 0.

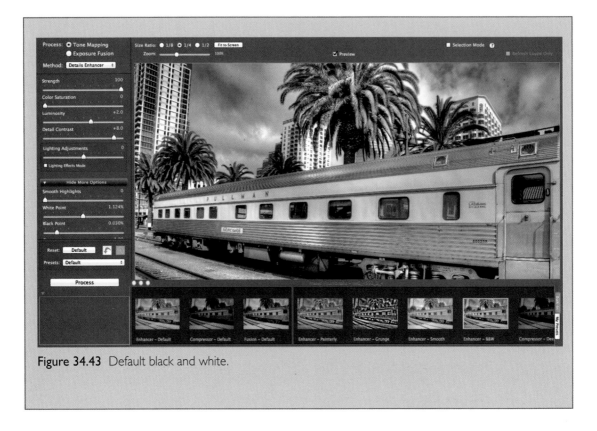

Figure 34.43 Default black and white.

Exposure Fusion

Sometimes tone mapping just doesn't work. In that case, you have to combine images with Exposure Fusion so they are more natural-looking. If you're looking for a realistic-type image with some detail (more than one photo by itself) in the highlights and shadows, then Exposure Fusion is the option for you. Exposure Fusion requires a lot less tweaking than tone mapping an image does; it turns out images in the "normal" range because there's less clipping and noise and fewer halos.

Like Tone Mapping, there are three windows in which to make your tweaks: the Adjustments window, the Preview window, and the Thumbnails window, as shown in Figure 35.1. You can see the different Exposure Fusion methods by navigating to the drop-down choices in the Adjustments window (Figure 35.1) or by clicking on any one of the Exposure Fusion thumbnails in the Thumbnail Presets window. They are Fusion-Adjust, Fusion-Intensive, Average, Fusion-Auto, and Fusion-2 Images. Unlike with Tone Mapping, most of the controls in Exposure Fusion don't affect the image much. In most cases, it's probably best to use Adobe Camera Raw (ACR).

Figure 35.1 Navigate to an Exposure Fusion method with the drop-down menu bar in the Adjustments window.

Exposure Fusion is low dynamic range, but it still uses the information from each of the exposures to create a new image. You can use Exposure Fusion when you have three different apertures, and you can work with it to create new depths of field. Exposure Fusion expands the process of merging photos to include additional photo sets, not just ones with varying exposure compensations taken at the same aperture.

The steps to make a photo using Exposure Fusion process are the same as those used for Tone Mapping, but there are fewer sliders to tweak, and each slider provides only minimal changes in the image after it's merged.

Figure 35.2 shows the default image for Fusion-Adjust. If you are working on it and don't like what you've come up with, click on the Reset: Default button located in the bottom-left part of the window.

Figure 35.2 Default Fusion-Adjust slider settings.

You can compare the default image shown to the images below to see what happens when an individual adjustment is made to any one slider.

The presets from which you can make your Exposure Fusion choice are in a separate window at the bottom of the screen: the Thumbnail Presets window. It's the same window that you see when viewing the Tone Mapping > Details Enhancer. To see the Exposure Fusion choices, use two fingers to swipe to the left on the multitouch surface on a Macbook (or use arrow keys, which work both on a Mac and in Windows). The Exposure Fusion preset choices are at the end of the window, as shown on the bottom-right side of Figure 35.2.

Exposure Fusion Sliders

Unlike Tone Mapping compression, Exposure Fusion enables local contrast. It tweaks brightness locally, so not all pixels in the photo are affected by the brightness change.

Fusion-Adjust

When you use Fusion-Adjust in the Adjustments window, you get a set of sliders that don't change the image much when you tweak them. You'll get much more dramatic results by processing and saving the default and then importing it into ACR for further tweaks.

The sliders include Accentuation, Blending Point, Shadows, Sharpness, Color Saturation, White Clip, Black Clip, and Midtones Adjustment. At the bottom of the Adjustments window is a Reset button to return the image to the default values after you've tweaked them.

The first slider in the Adjustments window—Accentuation—is for making subtle lighting changes and local contrast to the image. Move it to the right, and the image gets a bit brighter; move it to the left, and it gets a bit darker. It looks similar to the Painterly preset when you navigate to Tone Mapping > Enhancer.

The Blending Point slider controls how much you use of the under- and overexposures. Move the slider to the left, and you get a more underexposed image and a negative value. Move it to the right, and you get a more overexposed image.

> **N O T E**
> Use the Blending Point slider before you use the Accentuation slider. The Blending Point slider changes the image much more dramatically than when you tweak with the Accentuation slider.

The Shadows slider brightens only the shadows, not the highlights. This tweak offers changes that can be hard to notice if you aren't looking carefully at your photo.

The Sharpness slider sharpens minimally. It mostly increases contrast to give the impression of image sharpening. The downside is that increasing the Sharpness causes noise and halos in some images.

The Color Saturation slider does the same thing in Exposure Fusion as it does in Tone Mapping.

The White Clip/Black Clip sliders increase the contrast in highlights (white clip) or in the shadows (black clip). Increase either of them, and you lose detail where the contrast is increased.

The Midtones Adjustment slider works on brightness and contrast. This image needs to be lighter. For this reason, you want to move the slider to the right, as shown in Figure 35.3, where the midtones have been adjusted from a default of 0 to a value of 6. When adjusting the slider to the right, you remove a small amount of contrast. The opposite happens when moving the slider to the left: light is decreased, and contrast is increased.

Figure 35.3 Midtone adjustment of image in Exposure Fusion.

Fusion-Intensive

Fusion-Intensive is a preset with three slider controls, shown in Figure 35.4.

The three sliders are Strength, Color Saturation, and Radius. Each one affects what the other does. The Strength slider adjusts local contrasts. The Color Saturation adjusts the color intensity, and the Radius adjusts the weight given to the effect of each of the exposures on the preview image.

The less you tweak the Strength, the less the Radius changes when the slider is moved. Increasing the Strength causes additional changes in the image when the Radius slider is tweaked, as shown in Figure 35.5. The Strength and Radius increase from 0 to 6 and from 70 to 160, respectively.

Figure 35.6 shows how to change the sliders to the values that make the Fusion-Intensive image look best.

Figure 35.4 Default Fusion-Intensive.

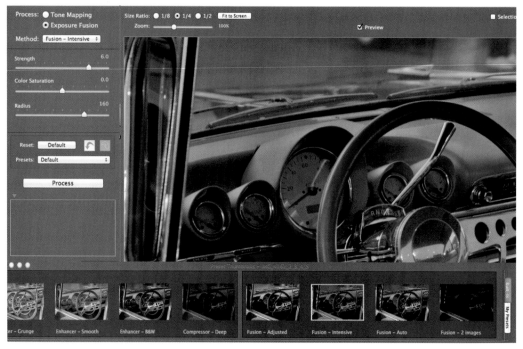

Figure 35.5 Fusion-Intensive with tweaks.

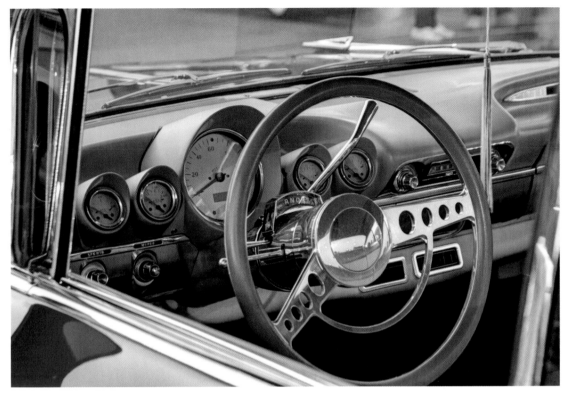

Figure 35.6 Image after tweaking sliders in Fusion-Intensive.

Other Fusion Methods

There are three other methods for Exposure Fusion: Average, Fusion-Auto, and Fusion-2 Images. The first two have no sliders and automatically make a tweak. The Average method makes most images too dark, and the Fusion-Auto method moderately decreases the brightness of the image.

Fusion-2 Images is an interesting way to choose the exposures you want to merge. It lists the different exposures that you uploaded to Photomatix and lets you pair up any two images for merging. Figure 35.7 shows you what happens when I combine the two most overexposed photos. As you can see, the result is dark. It's much darker for other matching pairs.

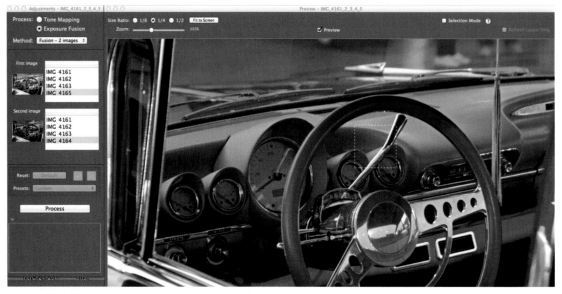

Figure 35.7 Fusion-2 Images merges any two of your exposures.

NOTE

When you choose an image filename in Fusion-2 Images, the program automatically changes the names of various files associated with that image so that you never merge the same two images.

Photoshop Elements Quick Merge

Using Photoshop Elements to make a high dynamic range (HDR)-like photograph is a unique process that requires some knowledge of the program. This chapter gives step-by-step directions for using the program to create some captivating merged images.

Automatic Merging in Photoshop Elements

The first thing you need to know before you get started is that Elements does not have antighosting or aligning tools. That's a drawback, but it shouldn't prevent you from merging photos without moving figures/objects. If you do have moving figures/objects, there are options to replace the figures/objects with still ones from one of your exposures.

Finding images to merge in Elements can be a challenge. The more images you merge, the better chance that one of them will be misaligned, ruining the final merged one.

The tricky part is determining which image is messing up the composition. It requires clicking indiscriminately until you find the image (images) that are out of alignment. Figures 36.1 to 36.3 show the results of the images I found aligned.

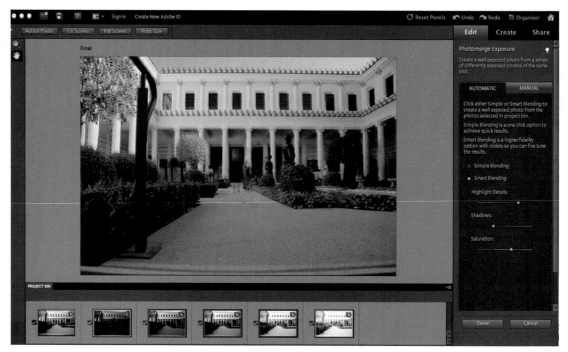

Figure 36.1 You have to click on different combinations of thumbnails to find out which image or images are not aligned.

Figure 36.2 Two images work fine to enhance details in shadowed areas.

Figure 36.3 Five of the images out of six are aligned.

Figure 36.4 shows some major misalignment due to the first image being added to the merge. In other HDR merging programs, you can automatically align the photos while they are processing. In Elements, however, you have to play around with the images until you get a combination that isn't misaligned.

Figure 36.4 The first image causes the misalignment.

The results of the HDR merging features of Photoshop Elements 8–10 are quite subtle, with not nearly as much of a painterly or surreal look as Photomatix or Photoshop HDR Pro. For merged images with all bright tones, there's hardly a difference between the normally exposed image and the merged image from different exposures. However, the feature brings out the details in the merged photos in areas that contain blown highlights in the normal exposures and overexposures by using the darker details from the underexposure. (See Figure 36.5.) It also brings out the details in the heavily shadowed area of normally exposed and underexposed by using the details in the overexposure.

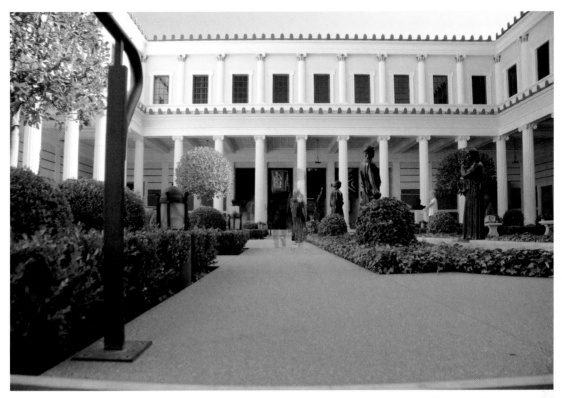

Figure 36.5 A photo merged from three shots of different exposures in Photoshop Elements 10.

Quick Merging into Faux HDR

Faux HDR using the Photomerge Exposure option in Photoshop Elements does a great job of creating an image that has depth and detail in areas of heavy shadows or bright highlights. The result is a compelling, sharp image that is almost indistinguishable from an HDR-like image made with Photoshop HDR Pro or Photomatix. Here's what to do:

1. Locate the files you want to merge by navigating to them on your computer.
2. Shift-click on the files you want to move to the Project Bin.
3. Click and drag images from the Desktop Navigation window into the Photoshop Elements Project Bin or Organizer (Figure 36.6), the large frame occupying most of the window. The images appear in Adobe Camera Raw (ACR).

Figure 36.6 Click and drag your images into the Organizer.

4. Shift-click on each image to select it, or click on Select All in the top-left corner of the Camera Raw dialog box. Then click Open Images, as shown in Figure 36.7. When you open the images, they appear in the Project Bin.

5. Select all the photos in the Project Bin by Shift-clicking each. Then navigate to New > Photomerge Exposure (see Figure 36.8).

> **NOTE**
> Click Photo once in the Project Bin to select it; double-click to show it in the Organizer.

6. Two choices exist for tweaking the final merge: Simple and Smart Blending. If you choose Simple Blending, not much happens, so I suggest Smart Blending. With Smart Blending, you have three control sliders: Highlight Details, Shadows, and Saturation.

7. Tweak the sliders to your liking and click Done (see Figure 36.9).

8. In the next window, which shows the merged image, navigate to Layer > Flatten Image.

9. Save by navigating to File > Save As. Type in a name for the file and click on Save in the Save As dialog box.

Figure 36.7 Select all images and open them in Organizer.

Figure 36.8 Select all three exposures and then merge them.

Figure 36.9 Adjust the sliders.

The resulting image (with a little additional rotating and cropping) is shown in Figure 36.10.

Figure 36.10 Cropped image merged using Photoshop Elements and tweaked in ACR.

Manual Mode

Merging using Manual Mode is a bit more work, but it's well worth it. The results are not quite as good as you can get in other high dynamic range (HDR) creation programs, but going thorough the process teaches you a lot about how to use Elements.

You can get started with the manual process after you've loaded some new images and merged them by doing steps 1–5 in the Chapter 36 section called "Quick Merging into Faux HDR."

Click the Manual Mode tab that you see in Figure 36.9 from Chapter 36, and the screen changes to what you see in Figure 37.1.

Figure 37.1 Options in Manual Mode for merging photos.

Follow these steps to merge your photos:

1. Click and drag the normally exposed image into the right window that you see in Figure 37.2. If it is the best exposure, this will be your background layer. If another photo is the best exposure, click and drag that one.

> **NOTE**
>
> Elements considers the midtones first when merging a photo—hence the reason for picking the best exposed one.

2. Click and drag the overexposed photo for the foreground, or double-click on the image to automatically drag it, as shown in Figure 37.3.

Figure 37.2 The best exposed image is dragged into the right window.

Figure 37.3 Selection tool action on overexposed photo in Foreground window.

3. Click on the Selection tool. (It has a pencil icon by it.) The bushes turn light green in the image that was placed in the background (right) window when a line is drawn in the foreground image in the left window.

 Look at what you want to copy from the foreground image into the background image. Click and drag the Selection tool to draw a line on that part of the photo (in this case, the trees). If you drew the line and changed what you wanted, go to step 5.

4. Fine-tune areas you might have missed by clicking on the magnifying glass, using the slider to make your brush size smaller and drawing small, thin lines in missed areas. I've drawn a small blue horizontal thin line between the buildings in the middle of the image (see Figure 37.4).

Figure 37.4 Tools for enlarging the photo and changing the brush size for fine-tuning pencil selections.

N O T E

If you make a mistake and choose too much or too little of the foreground to go in the background, correct it by clicking on the Eraser tool and removing or adding part of the line or erasing the line and clicking and dragging a vertical line instead.

5. Use thick horizontal lines to fill large spaces and thin vertical lines to fill small spaces.

6. Repeat steps 2, 3, and 4 for the underexposed or the next photo (if more than three are used), as shown in Figure 37.5. Click Done.

Figure 37.5 Line choices to finish cleaning up the tweaks with the selection tool.

> **NOTE**
>
> You can tweak the transparency of your pencil actions by using the slider at the bottom right of the Manual frame.

7. In the next window, you'll see that Elements has created two layers. Go ahead and merge those layers by navigating to Layer > Flatten Image. To view the image as it is after this step, see Figure 37.6.

8. You can use the Smart Fix in Elements to brighten your merged image by navigating to Enhance > Auto Smart Fix, as shown in Figure 37.7.

9. Save the photo by navigating to File > Save As and then providing a name for the file in the Save As dialog box. You can leave everything else in that box to the set defaults that Elements has checked.

Figure 37.6 Image showing the enhanced detail in the trees and sky.

Figure 37.7 Brightening your merged image with Auto Smart Fix.

You can tweak further in Elements. Here are the steps for Elements:

1. Choose Layer > Duplicate Layer.

2. Choose Enhance > Adjust Color > Remove Color.

3. Navigate to Soft Light in the drop-down menu bar of the Layers palette, as shown in Figure 37.8. Note that a layer mask was added to the Layers palette (Figure 37.9).

Figure 37.8 Navigate to Soft Light in the Layers palette.

4. Choose Enhance > Adjust Lighting > Shadows and Highlights. Move all three sliders to their max values, and click OK (Figure 37.10).

5. Click on the Magic Wand tool. Make sure Contiguous is not selected in the top menu bar. Zoom in (View > Zoom In), and click on the entire sky (Figure 37.11). Keep selecting by clicking while holding down the Shift key. (If you click on an area you don't want selected, hold down the Option key while clicking.) The selection will find the edges. To select more of an area, increase the Tolerance by inputting a number up to 100%. Decrease it by inputting a lower number. Use lower numbers when you are in tight spaces.

Figure 37.9 Image with Soft Light tweak.

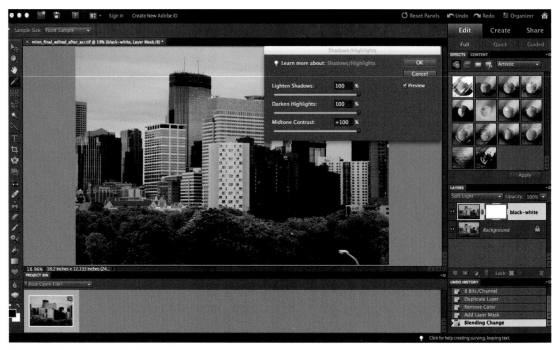

Figure 37.10 Shadows/Highlights at max values.

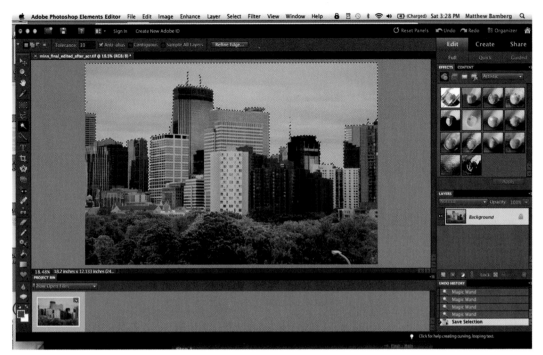

Figure 37.11 Select the sky.

NOTE

If the sky is broken up, select one area at a time.

6. Click on the Selection Brush tool in the Tools palette and choose the Mask from the drop-down menu bar option in the Options bar on the horizontal panel of settings at the top of the window. Set the Hardness and Overlay settings to around 100%.

7. Paint over any of the areas that you do not want to make darker (see Figure 37.12).

8. Click on Levels from the drop-down menu bar, as shown in Figure 37.13.

9. Adjust the histogram slider in the bottom-right part of the window so that the three points on it are closer together. Move the black and gray slider handles to the right to darken and the white slider handle to the left to lighten (Figure 37.14).

Figure 37.12 The Selection Brush tool marks out the part of the image you do not want to tweak.

Figure 37.13 Click on Levels to tweak the sky.

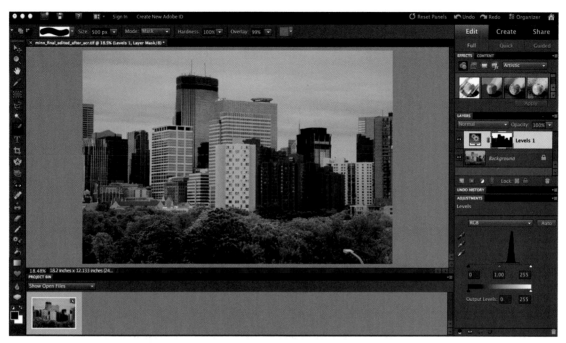

Figure 37.14 Options that appear when you click Levels.

> **NOTE**
>
> Magnify the image to evaluate the amount of noise you are creating with the sky tweaks.

10. Click on the Layer Mask thumbnail in the Layers palette. Then navigate to the Select menu and click on Refine Edge. (The dialog box will change its name to Refine Mask.) In the dialog box that appears, click on the blue icon (Standard), as shown in Figure 37.15.

11. Click on View > Selection to hide the selection edges. The blinking dashed lines disappear.

12. Tweak the Feather slider while watching the edges of your selection. Stop when the selection is cleaned up. Don't worry about the halo; that'll be cleaned up in the next step (see Figure 37.16).

13. Click and drag the Contract/Expand slider right until the halos disappear. Then click OK.

14. Create a new layer (Layer > New Layer). Click on the Mode drop-down menu bar and navigate to Soft Light. Then click OK. Figure 37.17 shows the Soft Light choice for Mode.

15. Choose Enhance > Adjust Lighting > Shadows/Highlights and raise all three sliders (Lighten Shadows, Darken Highlights, and Midtone Contrast) to +100, as shown in Figure 37.18. Click OK.

Figure 37.15 Standard is selected.

Figure 37.16 Tweak the Feather slider so the edges are softened.

Figure 37.17 Choose Soft Light.

Figure 37.18 Sliders set at +100.

16. Navigate to Layer > New to create a new layer (Layer 2).

17. Navigate to High Pass Filter > Other > High Pass, as shown in Figure 37.19.

Figure 37.19 Click on High Pass from the drop-down menu bar.

18. Click and drag the High Pass slider to the right to make the image as surreal as you like it (Figure 37.20).

19. Click and drag the Opacity slider in the Layers palette to get the softened contrast to your taste, as shown in Figure 37.21.

20. Flatten the image (Layer > Flatten Image), as shown in Figure 37.22.

You're done! Now you can remove noise or make other tweaks in a noise reduction program or in ACR.

Figure 37.20 Set the High Pass slider to 100.

Figure 37.21 Soften Contrast.

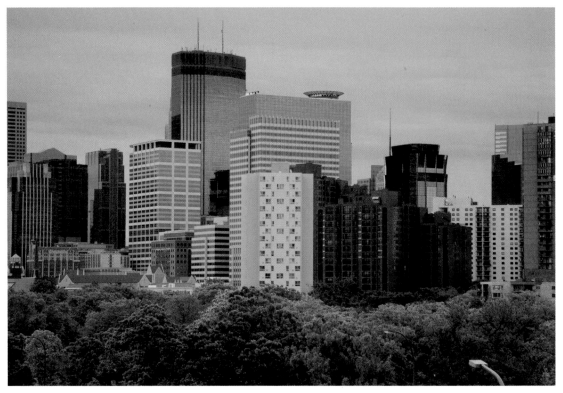

Figure 37.22 Final image after noise removal.

PART VIII

Printing HDR Photos

Printers and Computers

The first thing you'll want to consider regarding computers is licensing for Photomatix, which you can use on your PC or your Mac. You can put Photomatix on two computers if you register the software in your name. You have to get a second license if you install the program under a different user.

If Photomatix runs erratically, make sure your computer meets the system requirements to run the program: 2 GB of RAM, 500 MB of hard drive space, 1024 × 768 screen resolution , and a 16-bit color monitor.

If you have too many programs open at once, HDR processing slows down considerably. Close all windows and programs you are not using with any of the HDR processing programs.

When considering a printer, you need to evaluate what you want to do with your work. If you just want 8 × 10 prints, you can choose from a plethora of ink-jet printers. However, most people opt for a printer that prints photos wider than 10 inches.

Special printers made for fine art photography are available for consumers from HP, Epson, and Canon. These are the types of printers you should get if you choose to print your own photos.

Printers over 17 inches don't indicate the length of your print because they can handle paper rolls, which print long photos (banners) with a specific width that matches the size of the printer.

Large-format printers used by professionals for fine art photography are not all that expensive. You can get a good printer for HDR photos for less than $1,000, but for business printing, framing, and selling your work, a printer should be at least 17 inches wide so you can print enlarged photos. Keep in mind, also, that paper and ink will be an ongoing expense.

If you're in the market to print 16-bit prints, you need a printer like the Epson Stylus Pro 3880 (17-inch) shown in Figure 38.1, HP's Photosmart Pro B9180 (19-inch), or the Canon ImagePROGRAF iPF6100 (24-inch). You have to at least open your 16-bit images in Photoshop CS4–5, Lightroom2–3, or Aperture 2–3 because this is the only software that can transmit a 16-bit image to the computer. Most beginners needn't worry about that because there is little difference in image quality between a 16-bit and an 8-bit print.

One word of warning: If you think you want to print extra-large prints, make sure you'll be printing them often enough to warrant buying a printer that can handle them. When you don't use a printer frequently, the ink heads dry out, and it takes a lot of troubleshooting to get them operating efficiently again.

N O T E

Windows 8 is the first consumer platform to offer 16-bit printing for PCs.

Figure 38.1 Epson Stylus Pro 3880 with ink, Courtesy of Epson.com.

The most important thing you can do to minimize image degradation is to work in 16 bit until you're ready to print and then convert to 8 bit if you so choose. Keep in mind that monitors show one set of colors and printers print using another. Because many photographers think it is important to buy or create their own custom color profiles, they want to have the option of using the monitor colors to show what the printer will print, taking into account the type of paper you are using. (This is called a soft proof.)

Printers can't process certain colors that are displayed on the monitor, yet they can process some colors that the monitor can't. Much of this color transfer ends up being negligible in the final print.

Workflow

hen you're printing extra large photos, it's best to go with 16-bit printing. Anything larger than 12 × 18 at 360 ppi is prime for using 16-bit printing.

Even when you print at 8 bit, the advantages of keeping the image at 16 bit throughout the printing process outweigh the extra memory used on your computer because you're working with more color information when editing, and your image will not degrade as much as it would when editing in 8-bit mode. The ability to output a 16-bit image to print depends on many things: your specific operating system, the version of Photoshop, Lightroom, or Aperture you are using, the make and model of your printer, and the capability of your printer driver.

Printing an HDR photo is no different from printing other fine art photography photos. To get the colors correct on a print, you need to calibrate your printer. Tools such as Pantone Huey Pro help you calibrate your monitor as accurately as possible to keep the colors of your printed image consistent with what you see on your monitor. This doesn't mean you can't calibrate your monitor using your computer's software. You can, and the job it does is decent enough, but infrequently it can fail, leaving you with a large printed image that you can't use, especially if it hasn't been calibrated longer than one or two months. At the very least, you should calibrate your monitor if you are not going to invest in more specialized software to do it.

In the previous chapter, I defined what a soft proof is and explained that you use Photoshop to determine the colors that appear on the print, instead of the printer deciding what colors it will print. This process is called color management and is for fine art photography only. If you are using your images for anything other than for fine art photography, you can use any printer and let it decide the colors. Fine art photography printing requires a somewhat complex workflow. Serious hobbyists and professionals who wish to print the photos they sell have to put a great deal of time and effort to make salable prints. The options you choose depend on many factors, such as paper type, printer type, paper you are going to use (glossy/matte), and ink. The information is imported into Photoshop in the form of an International Color Consortium (ICC) profile, which contains the necessary profile in a file to print your image. You can find and download an ICC profile at your printer manufacturer's website.

NOTE
Before you make a large print, print a small copy on 11-inch paper to preview it so that if your print isn't what you expect, you won't have wasted expensive paper.

Paper and Ink

It's best to go with pigmented ink for printing on an ink-jet printer. These inks are archival, meaning that images printed with them can last longer than a lifetime. You can test the paper you have purchased by imprinting an image on it with pigmented ink and placing it outside in the sun for days to see if the ink fades. Although I don't recommend you do that with your photos, it does illustrate how fade resistant the ink is. Manufacturers have tested many types of paper and ink. Wilhelm Imaging Research (www.wilhelm-research.com/) has many articles discussing the results of these tests.

Look for a printer that takes three black inks: Black, Light Black, and Light Light Black. You also want a printer that takes larger print cartridges, because they contain more ink at a better price. (You don't want to be inkless at an inopportune moment.) Some printers have one slot for the three inks, meaning that you have to swap cartridges depending on what you're in the mood for. This is more common in cheap printers.

Regarding paper, make sure you check the printer manufacturers guidelines about which paper to use for the highest-quality prints. Don't use cheaper versions from a third party or a different manufacturer unless the guidelines state specifically that the manufacturer's paper is okay to use on the printer. If you want to use metallic paper, Red River Polar Pearl Metallic will do just fine with an Epson printer. If you're using an Epson printer, Epson Velvet Fine Art Paper is a good choice. The paper is archival (lasts more than a lifetime) and acid-free. Epson Exhibition Fiber and Epson Ultra Premium Photo Paper Luster are great for HDR photo printing because they can handle the bold colors, wide exposure range, and minute details that an HDR or tone-mapped image contains.

If you want to sell medium-end photography, you can use any paper you like. I've sold medium-end prints and used premium glossy and matte paper. Just to give you an idea of the range of papers you can use, the Epson R3880 can print on the following types of paper:

- Plain Paper
- Epson Bright White Paper
- Presentation Paper Matte
- Premium Presentation Paper Matte
- Premium Presentation Paper Matte Double-Sided
- Ultra Premium Presentation Paper Matte
- Photo Paper Glossy
- Premium Photo Paper Glossy
- Premium Photo Paper Semi-Gloss
- Ultra Premium Photo Paper Luster
- Exhibition Fiber Paper
- Watercolor Paper Radiant White
- Velvet Fine Art Paper
- UltraSmooth Fine Art Paper
- Premium Canvas Satin
- Premium Canvas Matte
- PremierArt Matte Scrapbook Photo Paper

The best papers for HDR printing are those that don't reflect light much. Glossy and premium glossy papers won't do an HDR photo justice because the fine details could be blocked by a large reflection of light. Matte papers are excellent for picking up all the details without giving off reflected light (glare).

Also important is the type of photography you are printing. Landscapes look great on cotton paper (rag). Black-and-white photography is best printed on pure white paper. Most photo paper manufacturers offer some type of canvas. You can create a painting-like photo using canvas and an HDR image made with a Painterly preset.

Ink is just as important as paper for a high-quality print. Avoid using dye-based inks because they fade much more quickly than their pigment counterparts; thus, any benefit they may have at the outset is eventually erased. The three major manufacturers of inkjet printers today are Epson, Canon, and HP.

How many inks are installed? It depends. Epson's Ultrachrome K3 inks with Vivid Magenta come with nine: four blacks (including matte black), cyan, vivid magenta, light cyan, light vivid magenta, and yellow. The new Ultrachrome HDR inks add green and orange to the mix. The green and orange inks improve the creation of yellow (mixture of half-green and half-orange), a once-difficult color to print with ink colors of the past. Ultrachrome ink allows a greater density of ink to get to the paper than traditional inks have, thus increasing the color gamut and improving the black and gray tones necessary for HDR photos.

If you intend to print a lot and want to minimize your costs, go for a printer that has larger ink tanks installed, not the small cartridges found on 13-inch or smaller printers. The cost per print will be much less. The larger tanks are usually installed on the 17-inch and higher printers and range anywhere from 80 to 220 ml per tank. A 17-inch printer may end up costing less than a 13-inch printer because it ships with a full set of much larger ink tanks.

If you want to outsource your printing, here are a few choices: White House Custom Colour (WHCC), PEphoto.com, QOOP.com, Photoworks.com, Shutterfly.com, mpix.com, Adorama.com, and Snapfish.com. Each has a wide selection of sizes and paper you can choose from. Print quality varies from lab to lab, so have labs print some of your photos to see which provides the best result. If you have a lot of printing to do, you can even ask the printing lab for samples of its prints.

Index